THE LONDON, MIDLAND SCOTTISH RAILWAY

—— VOLUME 1 ——

CHESTER TO HOLYHEAD

Stanley C. Jenkins & Martin Loader

AMBERLEY

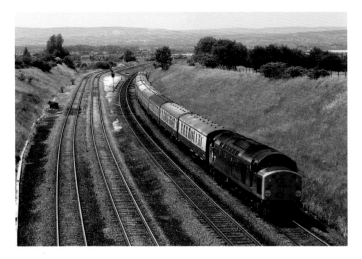

A Class '40' at Saltney Junction

Class '40' locomotive No. 40034 passes Saltney Junction with an eastbound passenger working in 1977.

ACKNOWLEDGEMENTS

The photographs used in this publication were obtained from the Lens of Sutton Collection, and from the authors' own collections.

A Note on Closure Dates

British Railways closure announcements referred to the first day upon which services would no longer run, which would normally have been a Monday. However, the final day of operation would usually have been the preceding Sunday (or, if there was no Sunday service, the preceding Saturday). In other words, closure would take place *on* a Saturday or Sunday, whereas the 'official' closure would become effective *with effect from* the following Monday.

First published 2015

Amberley Publishing
The Hill, Stroud, Gloucestershire, GL5 4EP
www.amberley-books.com

Copyright © Stanley C. Jenkins & Martin Loader, 2015

The right of Stanley C. Jenkins & Martin Loader to be identified as the Authors of this work has been asserted in accordance with the Copyrights, Designs and Patents Act 1988.

ISBN 978 1 4456 4389 2 (print)
ISBN 978 1 4456 4416 5 (ebook)

British Library Cataloguing in Publication Data.
A catalogue record for this book is available from the British Library.

Typesetting by Amberley Publishing.
Printed in Great Britain.

INTRODUCTION

ORIGINS OF THE CHESTER & HOLYHEAD RAILWAY

At the start of the nineteenth century the condition of Ireland was a matter of grave concern for successive British governments. Much of the island was backward, poverty-stricken and plagued by sectarian strife, and in an attempt to improve this lamentable situation, an 'Act of Union' was passed which became effective on 1 January 1801 – the implication being that Catholic emancipation would follow shortly afterwards, although in the event this entirely reasonable measure was not enacted until 1829.

In 1826, the Holyhead Road was completed throughout, with impressive suspension bridges over the River Conwy and across the Menai Straights, but with the rapid development of steam-worked railways, it was decided that the transport links between England and Ireland should be further strengthened by the provision of a main line railway between London and Dublin – the assumption being that such a line would improve the economic position of Ireland, while at the same time binding it ever more closely to the rest of the United Kingdom. In 1839, a government commission reported that the best route for the proposed Anglo-Irish line would be along the North Wales coast, and the Chester & Holyhead Railway was therefore formed with the aim of constructing a railway from Chester to Holyhead harbour.

The first proposals for a line from Chester along the North Wales coast were put forward in March 1840, but the project made little headway, in part because there was considerable indecision regarding the western terminus of the line – some experts having argued that Porth Dynllaen, on the Lleyn Peninsula, would be preferable to Holyhead, insofar as it would avoid the need for a major bridge across the Menai Straits. Oblivious to this argument, the promoters proceeded with their original scheme, and in November 1843 they gave formal notice that an application would be made to Parliament for an Act to authorise the construction of a 'railway with all proper works and conveniences connected therewith', commencing 'at or near the stations of the Chester & Birkenhead and the Chester & Crewe railways in the Parishes of Saint Oswald and Saint John the Baptist, or one of them, in the Liberties of the City of Chester', and terminating 'at or near the Old Custom House Quay, in the Parish of Holyhead'.

The Chester & Holyhead Railway Bill received the Royal Assent on 4 July 1844, and the promoters were thereby authorised to build an 85-mile main line along the North Wales coast, the engineer for the line being Robert Stephenson (1803–59). In physical terms the route presented huge problems. Running westwards from Chester, the first 45 miles of the line would follow an easy route alongside the Dee Estuary and thence along the North Wales coast, but at Conwy the railway would have to cross the tidal River Conwy, beyond which the line would be carried past the great towering headland at Penmaenmawr. Tunnels would be required at Penmaenrhos, Penmaenbach, Conwy and Penmaenmawr, together with three more in the

vicinity of Bangor, while to the west of Bangor the Menai Straits would have to be spanned by a bridge large enough to clear the masts of the largest vessels.

After much thought, and in consultation with William Fairbairn, Robert Stephenson decided that the two water crossings could be achieved by means of hollow 'tubular' bridges – the River Conwy being crossed by a single-span bridge, while the Menai Straits would be spanned by a much larger bridge with two water spans and two land approach spans. It was envisaged that the iron tubes required for both bridges would be fabricated on land and then floated into position on pontoons, hydraulic rams of the type invented by Joseph Bramah being utilised for the delicate process of raising the tubular spans into position.

The completed Menai bridge would have a total length of 1,841 feet; each of the water spanned a length of 460 feet, while the approach spans on either side would be somewhat shorter, with a length of 230 feet. The tubular spans would be erected in pairs so that there would be eight separate tubes in total, forming two continuous tubular girders with an overall length of 1,513 feet. These would be supported by substantial abutments placed on both the Caernarfon and Anglesey shores, together with three massive stone towers, the centre tower being constructed on a rocky island known as the Britannia Rock, which would give the bridge its name – 'The Britannia Tubular Bridge'.

CONSTRUCTION & OPENING

Construction of the railway began on 1 March 1845, while the foundation stones of the Conwy and Britannia bridges were laid in the early months of 1846. Despite the magnitude of their task, the railway builders made excellent progress, and on 4 April 1848

The Times was able to report that the Chester & Holyhead Railway was rapidly approaching completion. In the previous week, a party of directors, accompanied by the principal officers of the company, had 'proceeded from Chester to Holyhead for the purpose of inspecting the line from end to end, in order to determine the period when it might be opened throughout'.

It was also announced that 'preparations for lifting the tubes of the Conwy Bridge were completed, and the raising operations were about to commence'. Between Conwy and Bangor, everything was said to be 'ready for opening, although the Britannia Bridge across the Menai Straits was still under construction, both as respects the masonry and the tubes'. The centre pier on the Britannia Rock, upon which completion depended, was some 55 feet above high-water mark, leaving 50 feet still to be completed. The work was proceeding at the rate of about 12 feet in height per month, and more than half of the ironwork had been completed.

From Bangor to Holyhead, a distance of 24 miles, the line was 'in first rate order', and contemporary press reports pointed out that the Chester & Holyhead Railway route was 'almost a singular instance of a major project being delivered over by the contractor to the company in a completed state on the very day fixed by the contract'. At Holyhead, the arrangements made for proceeding with the new harbour were so satisfactory that the directors had 'decided that they would open the line throughout to Holyhead as soon as the Conwy Bridge was complete'.

It is perhaps worth pointing out that the Chester & Holyhead Railway was both a railway company and a steamship operator, a quartet of four iron-hulled paddle steamers having been ordered for service between Holyhead and Dublin – these four

vessels were named, in true patriotic fashion, *Cambria*, *Hibernia*, *Anglia* and *Scotia* in honour of the four British 'home nations'. Excellent progress having been made, the main portion of the line was opened between Chester and Bangor on 1 May 1848, while goods traffic commenced on 1 June. The Irish steamer service began on 1 August 1848, on which day the whole line was brought into use with the exception of a gap of about 4 miles at the Menai Straights, across which the passengers were carried 'in conveyances provided by the company'.

Work continued apace along the westernmost extremity of the route between Bangor and Holyhead, and in September 1848 Robert Stephenson reported that the only works remaining to be completed were 'about two miles of the Bangor contract', together with 'the second tube of the Conwy Bridge and the Britannia Bridge'. The engineer complained that the completion of the works in and around Bangor had 'been much delayed by the want of arrangement on the part of the contractor'. Problems had also arisen in respect of the three tunnels which, although constructed through hard rock, had required brick arching as a result of 'exposure to the actions of the atmosphere'. Apart from these problems, the other unfinished works on the line were said to be 'very inconsiderable', and it was anticipated that they would be completed 'in the course of November'.

As far as the progress of the bridge works was concerned, construction of the second tube of the Conwy Bridge was far advanced, and there was no doubt that it would be ready for lifting by the middle of October 1848. The tubes for the Britannia Bridge, and the 'stupendous tiers of masonry intended to support them', were 'advancing to their completion simultaneously, and as rapidly as was consistent with the safety of such a work'. Stephenson added

that about three-quarters of the masonry of the Britannia Bridge had been completed, and he calculated that the first tube would be ready for lifting to its place in the course of the next March or April. All things considered, the ironwork of the Britannia Bridge had progressed even more rapidly than had been expected, and the four large tubes were approaching completion.

The first attempt to move one of the pontoon-mounted tubes was made on 19 June 1849, but a capstan failed and a further attempt was made on the following day. Again, a capstan failed at a critical moment, and it appeared the tube would be carried away by the current. At this juncture an appeal was made to the many thousands of spectators, and hundreds of volunteers rushed forward to assist the workmen by hauling on a spare line. At length, the first tube was manoeuvred into position at the base of the towers, from where it could be raised by hydraulic power. The first tube was in position by 13 October 1849, and the second tube was in place by 7 January 1850.

Meanwhile, the shorter land tubes at each end of the bridge had been fabricated in situ with the aid of scaffolding, and it was therefore possible for a single line to be brought into use through the up tube on 5 March 1850, the first train being driven across the bridge by Robert Stephenson. The down line was brought into use on 19 October 1850, when the bridge was formally opened for double line working. The completed bridge was regarded as one of the wonders of the age, but, unfortunately, it had cost a total of £674,000, three times greater than Stephenson's original estimate.

SUBSEQUENT DEVELOPMENTS

Directors' reports suggested that, despite the huge cost of the Britannia Bridge, the Chester & Holyhead line was destined for

success. The traffic on the portion of the line to Bangor was estimated in the original parliamentary estimates at £1,100 per week, but this figure was exceeded 'within eight weeks of the opening of the railway and by July 1848 the traffic receipts were averaging £1,205 per week'. Following the commencement of the Irish steamer service, the receipts increased still further to an average of £2,207 per week, despite the fact that goods and mineral traffic had not yet developed and there was, at that time, still a break in the line.

It was unfortunate that the opening of the Chester & Holyhead line should have coincided with the very worst period of the Irish Famine, which devastated many areas and resulted in an armed insurrection in 1848. The C&HR directors nevertheless hoped that, before long, 'Ireland would be in a very satisfactory condition' and the company would have the whole trade between Ireland and England, which would be 'very large', with 16 million people on one side of St George's Channel and 8 million on the other. The company also benefited from a subsidy of £30,000 a year for the carriage of mails, and there was, in consequence, 'every prospect' that they would have a traffic of £5,000 per week, which would pay a very 'handsome dividend on the shares'.

Sadly, the subsequent history of the Chester & Holyhead company was far from satisfactory, the crippling cost of the Britannia Bridge having proved to be an insurmountable burden. Under these circumstances, the C&HR became increasingly dependent on the London & North Western Railway, and it came as no real surprise when, after an independent existence of fourteen years, the C&HR directors agreed that their undertaking would be leased to or amalgamated with the L&NWR at a price 'not exceeding £50 per £100 of stock'.

EXPANSION OF THE SYSTEM – BRANCH LINES & CONNECTIONS

Meanwhile, the opening of the Chester & Holyhead route had encouraged local interests to promote a number of connecting branch lines, one of the first to appear being the Bangor & Carnarvon Railway, which was sanctioned by Parliament on 20 May 1851 with powers for the construction of a 7-mile line from Menai Bridge to Caernarfon. The line was opened for mineral traffic between Menai Bridge and Port Dinorwic in March 1852, and completed throughout to Caernarfon on 1 July 1852, when passenger trains began running over the entire line. On 2 September 1867, a separate undertaking, known as the Carnarvonshire Railway, was opened between Caernarfon and Afon Wen, but there was no connection with the Bangor & Carnarvon line until 5 July 1870, when the 'Carnarvon Town' line was brought into use.

There was, at first, no direct rail line to Llandudno, although travellers wishing to visit that 'rapidly rising bathing place, so charmingly placed at the foot of the Great Orme's Head' were able to utilise the nearby station at Conwy, which had been opened by the C&HR on 1 May 1848. In 1853, an undertaking known as 'The St George's Harbour & Railway Company' was incorporated by Act of Parliament with powers for the construction of a harbour and other works at Llandudno, together with a branch railway from the Chester & Holyhead main line near Conwy. The capital was originally set at £150,000 in shares and £50,000 by loans, but this was subsequently reduced to just £70,000 in shares and £20,500 by loans – the harbour part of the scheme having been quietly dropped.

The branch was virtually complete by the summer of 1858, and on 12 June the *North Wales Chronicle* was able to report

that the new railway was 'a short line of three miles, diverging from the Chester & Holyhead Railway at Conwy, whence it is carried, on a low embankment for about half its distance, to Deganwy'. Workmen were busily laying the permanent way, although delays had been caused during the winter 'by the washing down of part of the river wall of the embankment'.

The Llandudno branch was opened on 1 October 1858, with a service of trains to and from Conwy, necessitating a reversal at Llandudno Junction, where a small station was provided. The line was worked by the L&NWR, and an Act obtained on 1 August 1861 permitted a lease or sale to the North Western company, although the final amalgamation did not take place until 1873.

In addition to its role as an interchange point for the Llandudno branch, Llandudno Junction was also the starting point for the picturesque Conwy Valley line, which was built in three stages over a period of twenty years. The story began in the 1850s, when 'The Conway & Llanrwst Railway' was formed with the aim of constructing an 11½-mile branch between Llanrwst and the C&HR main line near Conwy. The company was incorporated by Act of Parliament on 23 July 1860 with an authorised capital of £50,000 in £10 shares, together with a further £16,666 by loans. A second Act, obtained on 22 July 1861, permitted deviations of the authorised route, and allowed the promoters to raise an additional £10,000 in shares and £3,300 by loans.

The Conway & Llanrwst Railway presented few engineering problems and the line was opened on 17 June 1863. A few days later, the new branch line was transferred to the L&NWR at a rent equal to 5 per cent of the share capital, and in 1867 the Conway & Llanrwst Railway was fully absorbed by the London & North Western Railway. On 5 July 1865, the North Western obtained powers for a short extension from Llanrwst to Betws-y-Coed, which was opened on 6 April 1868.

It appeared that the Conwy Valley branch would terminate at Betws-y-Coed, and although there were plans for an extension to Blaenau Ffestiniog it was envisaged that any continuation beyond Betws-y-Coed would be built as a narrow gauge line. The L&NWR started building a 2-foot gauge line in the 1870s, but the company subsequently decided that a standard gauge railway would be constructed to Blaenau Ffestiniog, and by the mid-1870s the spectacular 'mountain' section of the Conwy Valley branch was taking shape in the wild, brooding landscape of North Wales.

Difficult terrain and the absence of roads presented many difficulties, while the 2-mile Ffestiniog Tunnel was driven through solid rock. At least one contractor gave up in despair, but the tunnel was eventually finished, and on 22 July 1879 trains were able to reach a temporary terminus just beyond the southern portal. The Conwy Valley branch was finally completed at the end of March 1881, when the L&NWR opened a new station at Blaenau Ffestiniog with extensive goods sidings and facilities for handling large quantities of slate.

To the east of Bangor, a 4-mile line had been built to serve the slate mining centre of Bethesda, the necessary powers having been obtained by the L&NWR on 6 August 1880, while the line was opened to passenger traffic on 1 July 1884. This short line, which commenced at Bethesda Junction, some 58 chains from Bangor station, was a steeply graded single-track line with intermediate stopping places at Felin Hen and Tregarth.

In the meantime, other branch lines had been promoted on Anglesey – the Anglesey Central Railway having been

incorporated on 13 July 1863 with powers for the construction of a railway from the C&HR station at Gaerwen to Amlwch, a distance of just under 19 miles. Construction was under way by 1864, and the first portion of the line, from Gaerwen to Llangefni, was opened for goods traffic in December of that year. Passenger traffic commenced on 8 March 1865, and the branch was opened throughout to its terminus at Amlwch, on 3 June 1867. A branch was subsequently opened from Holland Arms, near Gaerwen, to Red Wharf Bay, the latter route being completed throughout by 24 May 1909.

TRAIN SERVICES

The Irish services, which formed a vital link between London and Dublin, were the principal passenger workings on the Chester & Holyhead route. There were, in general, around half a dozen boat trains each way during the pre-Grouping period, all of these workings being run in connection with the Holyhead steamer services. In the 1890s, for example, there were five daily sailings from Holyhead, two of these being direct services to Dublin North Wall, while two served Kingstown and one sailed to and from Greenore – from where the L&NWR-owned Dundalk, Newry & Greenore Railway furnished a link to Belfast. The famous 'Irish Mail' service was inaugurated on 1 August 1848, and it could therefore claim to be the oldest named train in the world. When first introduced, the evening down working left Euston at 8.45 p.m., and was scheduled to arrive at Holyhead at 6.45 a.m. on the following morning.

As Llandudno grew in importance as a seaside 'watering place', it became especially popular among wealthy Lancashire businessmen who could afford to commute to and from Manchester or other industrial centres. Llandudno was also favoured as a 'health resort' for invalids and retired professional people, while ordinary working-class people visited the town as daytrippers. As a result of these developments, Llandudno became an important destination in its own right, with a range of useful services to Liverpool Lime Street, Manchester Exchange, Birmingham New Street and other great industrial cities in the North and Midlands.

The best 'residential' trains included the 8.10 a.m. to Manchester Exchange, which conveyed a Liverpool portion that was detached at Chester and reached Lime Street by 10.05 a.m., and a Mondays-only through service to Liverpool that left Llandudno at 8.20 a.m. and accomplished its journey in 105 minutes. There was also a Mondays-only train from Llandudno at 6.00 a.m. that reached Birmingham in a time of 3 hours 20 minutes. These services catered primarily for businessmen and professional people who were able to spend their weekends in the congenial surroundings of Llandudno and return to their workplaces early on Monday mornings – no doubt taking full advantage of the comfortable dining cars that the North Western provided for their benefit.

In this context, it is interesting to note that well-fitted 'club carriages' became a feature of operations at Llandudno during the pre-Grouping period, when groups of like-minded gentlemen formed exclusive 'travelling clubs', and special vehicles were provided by the railway companies so that these affluent individuals could, literally, travel to and from work in the comfort of their own leather-padded armchairs.

Train services on the local branch lines were adequate in relation to a sparsely-populated area such as North Wales.

In December 1889, for instance, the basic winter timetable on the Conwy Valley line consisted of just five up and five down workings, including an early morning down train from Llandudno Junction at 4.25 a.m., which reached Blaenau Ffestiniog at 6.10 a.m., and was used mainly by slate workers. Special workmen's tickets were available for use on this service, typical fares being 3*d* return from Betws-y-Coed and 2*s* 6*d* return from Pont-y-Pant. By the Edwardian period, an upsurge in tourist traffic on the Conwy Valley route had resulted in an improved timetable providing seven up and eight down passenger workings, together with several short distance services between Llandudno Junction and the popular tourist centre at Betws-y-Coed.

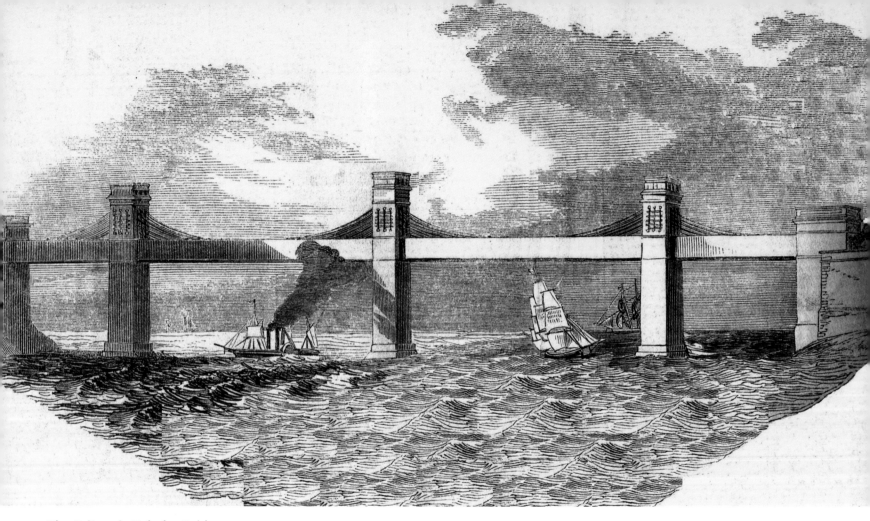

The Britannia Tubular Bridge
This artist's impression of the Britannia Tubular Bridge was published in the *Pictorial Times* on 21 March 1846. The picture is of particular interest in that it shows that suspension chains were part of the original design – indeed, the proposed bridge was described as a 'suspension railway tunnel' to be formed of 'strong iron beams ... which will be hollow to allow the passage of trains', this 'stupendous undertaking' being the 'first of its kind ever proposed'.

Crewe

Although the Chester & Holyhead Railway was constructed and opened as a railway between Chester and Holyhead, it could be argued that the present-day Chester & Holyhead route commences at Crewe – at which point diesel-worked Holyhead services leave the electrified West Coast Main Line. Historically, the Crewe to Chester line was an integral part of the London & North Western Railway, having been absorbed by that company under the provisions of an Act obtained on 19 May 1840.

However, when the British Rail system was privatised in 1996, the Crewe to Chester line was excluded from the WCML franchise, and the route is now worked by Arriva Trains Wales.

The upper picture provides a glimpse of Crewe station during the L&NWR era, a train of typical North Western coaches being visible to the right – these vehicles were painted dark purple-brown with white upper panels, while L&NWR locomotives were immaculately turned out in shining 'blackberry black' livery.

On leaving Crewe, C&HR services set out along the Chester & Crewe line, which runs for 21¼ miles across level Cheshire countryside. The line was opened on 1 October 1840 with intermediate stations at Worleston, Calveley and Beeston Castle; an additional stopping place was opened at Waverton in 1846, while Tattenhall Road was opened on 1 October 1872. All of these stations are now closed.

The lower picture shows class '150' unit No. 150218 heading eastward past the site of Beeston Castle station with a crew training run on 12 March 1987. This unit had only just entered service and was still wearing the original white-fronted livery with a yellow gangway door.

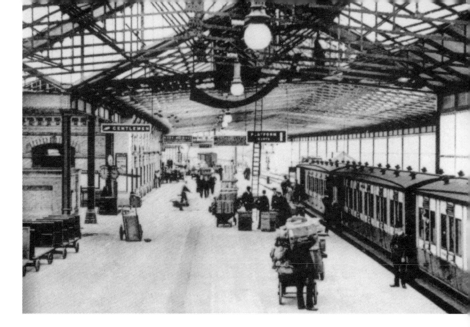

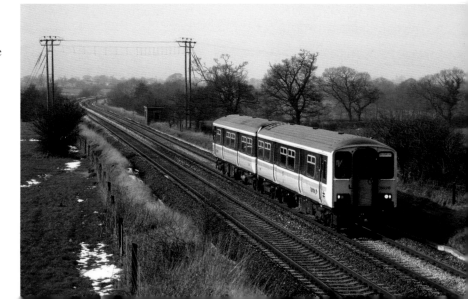

Left: Worleston

An Edwardian postcard view of Worleston station, looking west towards Chester and Holyhead. Worleston was 3¾ miles from Crewe, and when opened in 1848 it was known as 'Nantwich' – the name being changed in September 1858. The station building, on the down platform, was a picturesque 'country cottage' style structure that incorporated living accommodation for the stationmaster and his family, as well as the usual booking office and waiting room accommodation. The up and down platforms were linked by a lattice girder footbridge, and the goods yard was sited to the west of the platforms on the down side. This station was closed to passengers with effect from 1 September 1952, although the 15-lever signal box remained in operation until February 1969.

Right: Calveley

Class '37' locomotive No. 47423 Sir Murray Morrison (1873–1948), pioneer of the British aluminium industry, speeds through the remains of Calveley station with the 12.22 p.m. Bangor to Crewe service on 10 July 1999. The platforms here were bisected by a skew bridge that carries the A51 Chester to Crewe road across the railway, and this brick-built structure makes a neat frame for the picture. Calveley was originally known as 'Highwayside', but its name was changed at an early date. The Shropshire Union Canal was sited a short distance to the south of the station, and a gated siding branched out from the main line in order to reach the canal wharf, which was equipped with a goods transfer shed and a 10-ton crane. Calveley station was closed to passengers with effect from 7 March 1960, but goods services lingered on until November 1964.

Right: Waverton

Class '47' locomotive No. 47737 *Resurgent* passes Waverton with the 1.56 p.m. Holyhead to Birmingham New Street service on 16 August 2003. The train consisted of four First Great Western Mk 2 coaches in FGW green and off-white livery, while the locomotive was in 'Rail Express Systems' red livery – an unusual combination, but standard fare for this diagram during the summer of 2003.

Left: Waverton

Class '47' locomotive No. 47368 passes Hargrave, between Tattenham and Waverton, while hauling a Merry-go-Round coal working between Point of Ayr Colliery and Fiddlers Ferry Power Station on 12 March 1987. These workings were an important source of bulk freight traffic at the eastern end of the Chester & Holyhead route until the closure of the colliery in 1996.

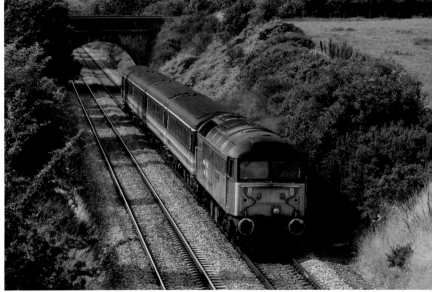

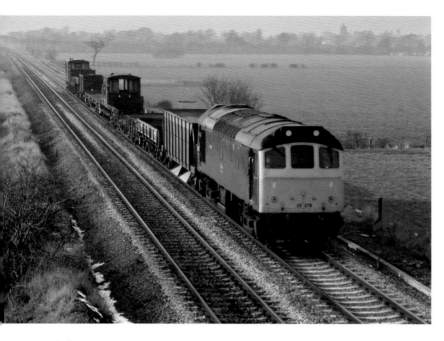

Right: Waverton

Less than 2 hours after class '25' No. 25278 had passed Hargrave on its outwards journey from Crewe, the locomotive returned in the eastwards direction with a slightly shorter engineers train. Of course in the intervening time the sun had moved around, so that neither picture has the sun on the front of the engine. In the event, No. 25278, along with several other members of the class, survived past the official switch off date, but only by one day. On 16 March, it ran out of 'A' exam hours after working a Bescot to Crewe freight, but happily the engine has survived in preservation on the North Yorkshire Moors Railway, where it has been restored to two-tone green livery with the name Sibilla. Waverton church can just be seen through the mist in the background.

Left: Waverton

Class '25' locomotive No. 25278 (unofficially named *Castell Harlech/Harlech Castle*) runs through Hargrave at the head of a Crewe to Chester engineers' train on 12 March 1987, just three days before the date upon which, according to rumour, all remaining class '25's would be switched off. It was a day of very weak spring sunshine, with remnants of snow still visible on the fields.

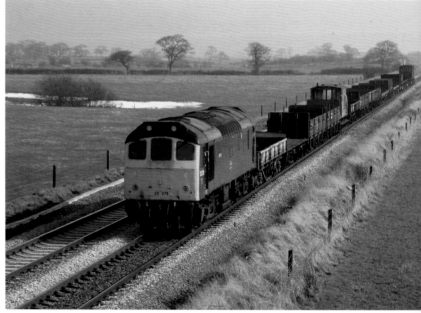

Chester General

Railway development in the Chester area began as far back as the 1830s, the Chester & Birkenhead Railway having been sanctioned by Parliament on 12 July 1837, while the Chester & Crewe Railway obtained its Act of Incorporation on 30 June 1837. These two lines were opened on 23 September 1840 and 1 October 1840 respectively – the Birkenhead line having a station at Grange Lane, while Chester & Crewe services ran to and from an entirely separate terminus. When opened on 4 November 1846, Shrewsbury & Chester Railway shared the Birkenhead Railway station, but in the event, these arrangements were merely temporary, and on 1 August 1848 a new 'General Station' was brought into use to serve the Chester & Holyhead, Shrewsbury & Chester, London & North Western and Birkenhead, and Lancashire & Cheshire Junction railways.

The new station was over a quarter of a mile in length and, as described in a report published in the *Liverpool Mercury* on 16 May 1848, the design was 'remarkable for its beauty and grandeur of proportion' and 'admirably adapted for the purpose for which it was erected'. The upper picture, taken from a contemporary engraving, shows the main station building during the 1840s. This two-storey, Italianate-style edifice was designed by Francis Thompson (1808–95), the Chester & Holyhead architect, and it incorporated east and west-facing bays – the terminal bays being, in the early days, regarded as separate 'Arrival' and 'Departure' stations. There was also a lengthy through platform along the northern side of the station. The lower view shows the very wide island platform that was later constructed to the north of the original platforms.

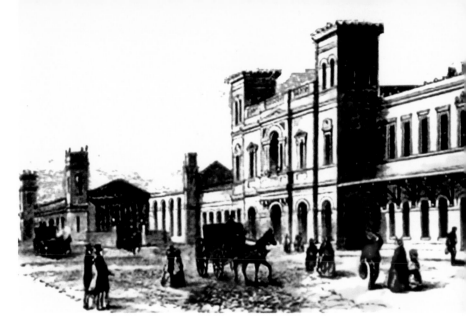

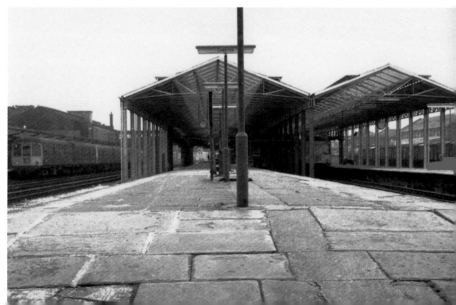

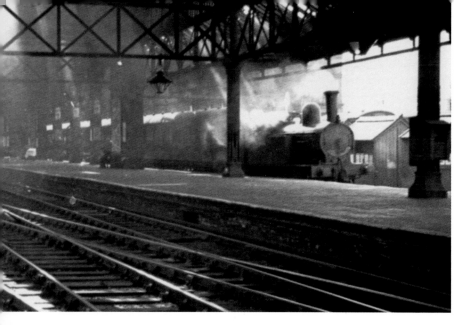

Chester General

Above: The platforms at Chester General were formerly covered by an overall roof which was, in effect, a series of parallel train sheds. In its description of the station, *The Liverpool Mercury* stated that some of these sheds were 'from 700 to 800 feet long' and 'covered with iron roofs remarkable for lightness and elegance'; they had been designed by 'Mr Wyld, civil engineer'. The train sheds have now been partially dismantled, although the earlier roof coverings have been partly replaced by modern canopies, and substantial train sheds still remain above the central parts of the station. In steam days, the interior of the station was a somewhat gloomy place, as exemplified by this *c.* 1930s view of a former London & North Western Railway tank locomotive shrouded in steam.

Below: There are, at present, seven platforms, Nos 3, 4 and 7 being the main through platforms, while Platforms 1 and 2 are east and west-facing terminal bays on the 'down' side, and Platforms 5 and 6 are east-facing bays on the 'up' side; the three through platforms are now signalled for bi-directional working. Platform 3 can accommodate eighteen coaches, while Platform 4 can hold up to fifteen bogie vehicles. The picture, taken in the 1960s, is looking east towards Platform 4, which is an island with tracks on either side; its northernmost face is divided into two sections known as Platforms '7a' and '7b' – Platform 7b is now used solely by Merseyrail Electric services. Chester & Holyhead services normally use through Platform 3, which is sub-divided into sections '3a' and '3b'.

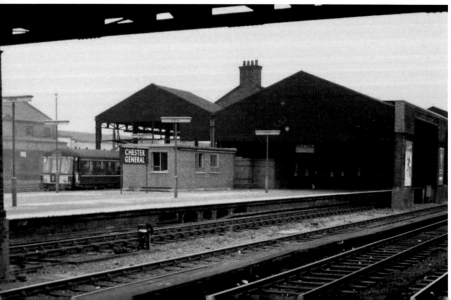

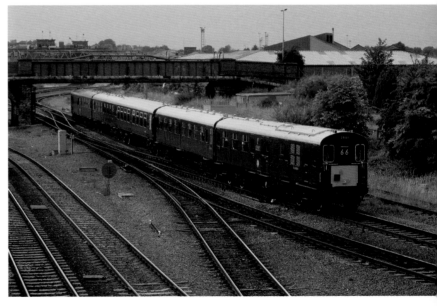

Left: **Chester General**

Class '56' locomotive No. 56007 passes through Chester on 17 August 1996 with the early running 5.28 p.m. Dee Marsh to Warrington Arpley Enterprise service, comprised entirely of empty OTA timber wagons from Shotton Paper Mill.

Right: **Chester General**

An unusual visitor at Chester on 17 August 1996, as Hastings six-car diesel unit No. 1001 (running as a five-car set) carries out a shunting manoeuvre prior to heading back towards more familiar territory with the Hastings Diesels Ltd 'Crewe & Chester DEMU' railtour. The leading vehicle is motor coach No. S60000 *Hastings*. The tour was run in connection with the Crewe Works Open Day, with the additional attraction of this extra mileage to Chester. Narrow-bodied trains of this type worked on the Southern Region's Charing Cross to Hastings route between 1957 and 1986 – unit 1001 being a preserved set that was returned to main line service in 1996. The trip to Crewe and Chester on 17 August 1996 was one of the first trips made by this immaculately restored train.

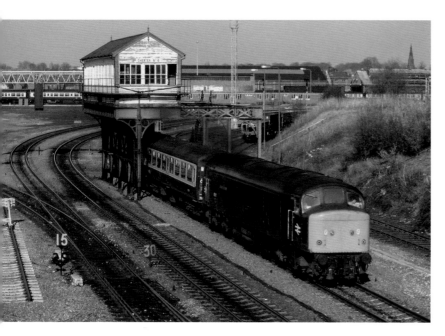

Right: Chester General

Class '37' locomotive No. 37401 *Mary Queen of Scots* approaches Chester with the 4.22 a.m. Holyhead to Birmingham New Street service on 10 July 1999. This was, at that time, the first class '37' hauled train of the day – the others being the 8.07 a.m. Birmingham to Bangor; the 11.16 a.m. Bangor to Birmingham; the 2.23 p.m. Birmingham to Holyhead; the 6.22 p.m. Holyhead to Stafford; and finally the 9.10 p.m. Stafford to Crewe empty coaching stock working.

Left: Chester General

On departing from Chester station, down trains run between rock cuttings and through short tunnels for a distance of about 1 mile. Northgate Street Tunnel takes the line beneath the site of the former Cheshire Lines Committee's Chester Northgate station, which is now a leisure centre, beyond which the C&HR route crosses the Shropshire Union Canal and then cuts through a corner of the famous city walls. With the Roodee racecourse now visible to the left, the railway approaches the River Dee, which is crossed by means of two parallel bridges. The upper picture shows class '45' locomotive No. 45111 *Grenadier Guardsman* passing beneath Chester No. 6 signal box, while hauling the 12.57 p.m. Scarborough to Bangor service on 24 April 1984. No. 45111 was withdrawn in 1987 and cut up in 1992, while the distinctive elevated signal cabin was closed in connection with the Chester area resignalling scheme in May 1984. The curve that can be seen to the left enabled trains from Wales (or the south) to run to or from Birkenhead without reversing in Chester station.

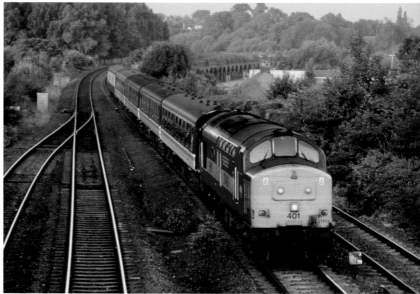

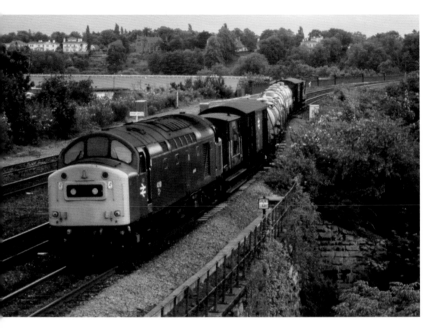

Right: Chester General – Crossing the Dee

Class '40' locomotive No. 40001 crosses the River Dee at Chester with a Holyhead bound freightliner working on 23 April 1977. This is a historic picture, as the gasworks are now a thing of the past, and No. 40001 was withdrawn for scrapping after twenty-six years of service in 1984.

Left: **Chester General – Passing the Roodee Racecourse**

Class '40' locomotive No. 40150 approaches Chester at the head of the Amlwch to Ellesmere Port chemical tanks on 29 June 1984. This locomotive is long gone, having been cut up in 1987, while chemical traffic from the Isle of Anglesey is also now a distant memory. The Roodee Racecourse can be seen in the background.

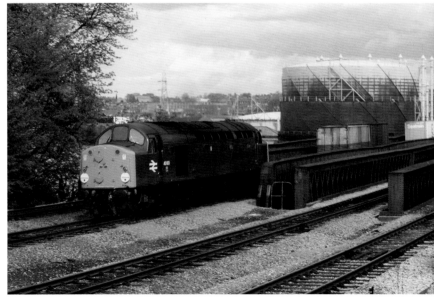

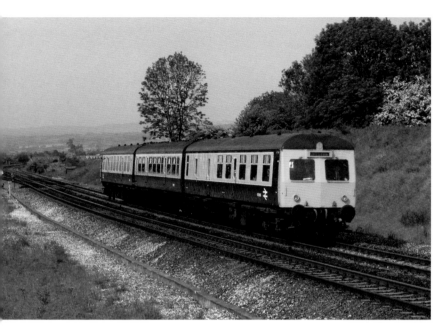

Right: Chester – Tickets

A selection of LMS and BR tickets from Chester and the eastern section of the Chester & Holyhead line, comprising a paper platform ticket and eight Edmondson cards. First-class tickets were normally white, whereas second- and third-class issues were printed on light greenish-grey cards.

Left: Saltney Ferry & Mold Junction

Continuing south-westwards, trains reach Saltney Junction, at which point the Shrewsbury & Chester line diverges southwards from the Chester & Holyhead route. The S&CR, which was opened between Chester and Ruabon in 1846 and completed throughout to Shrewsbury in 1848, became part of the Great Western Railway in 1854. The photograph shows a hybrid multiple unit formation led by a class '120' motor brake composite passing Saltney Junction with a Shrewsbury to Chester service on 7 June 1984. The centre car is an unidentified class '101' trailer second, while the trailing vehicle appears to be a class '120' motor second.

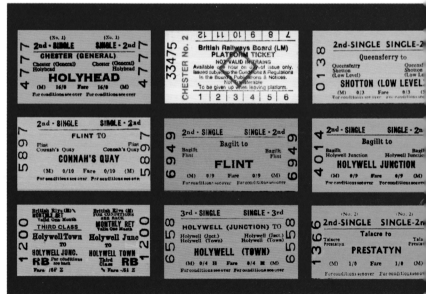

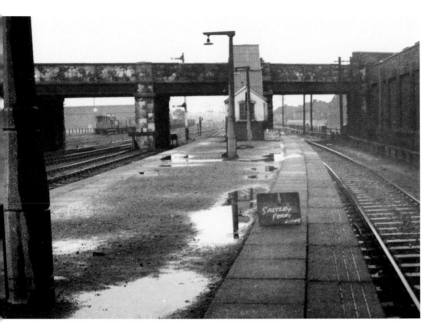

Left: **Saltney Ferry & Mold Junction**

Having passed Saltney Junction, Holyhead services head westwards to Saltney Ferry – the first intermediate stopping place on the C&HR route. This small station was opened on 1 January 1890 and closed with effect from 30 April 1962. Its facilities consisted of a single island platform, as shown in the accompanying photograph, which is looking east towards Chester; public access was by means of a flight of steps from the adjacent road overbridge. The Mold Junction engine shed was sited to the south of the platform, while Mold Junction, the starting point of the Mold branch, was immediately to the west of the station.

Right: **Saltney Ferry & Mold Junction**

This *c.* 1902 view, which is taken from an Edwardian colour-tinted postcard, provides a general view of the station, with the engine shed alongside. The shed building, dating from 1891, was a typical London & North Western structure with a 'northlight' pattern roof and eight shed roads. The shed, which was coded '6B' in BR days, normally housed about forty locomotives. In 1959, for example, the allocation included eleven Stanier 'Black Five' 4-6-0s; nine Stanier '6P5F' 2-6-0s; thirteen War Department 2-8-0s; three Stanier class '8F' 2-8-0s; four class '4F' 0-6-0s: and three class '3F' 0-6-0Ts – a total of forty-four locomotives. The shed was closed in 1966, but the 60-foot diameter turntable was taken to Rowsley South, for further service on the Peak Rail 'heritage' line.

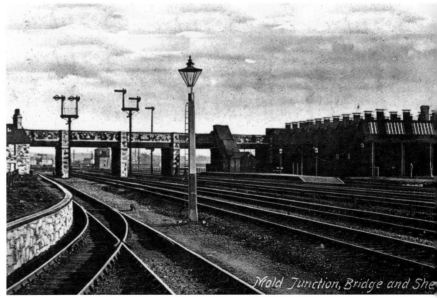

Mold Junction, Bridge and She[d]

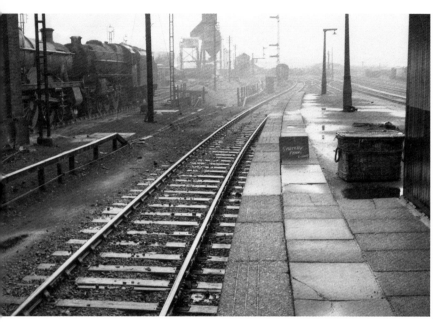

Left: Saltney Ferry & Mold Junction
Another view of the island platform, looking west towards Holyhead around 1962, with the engine shed to the left. An unidentified 'Black Five' 4-6-0 is standing outside the shed, together with a former Great Western 'Hall' class 4-6-0. The coaling plant can be seen in the distance, while Mold Junction goods yard can be glimpsed in the right background. As mentioned above, Saltney Ferry station was closed with effect from 30 April 1962, and Mold Junction goods yard was closed in May 1964 – although the nearby marshalling yard remained in use until October 1979.

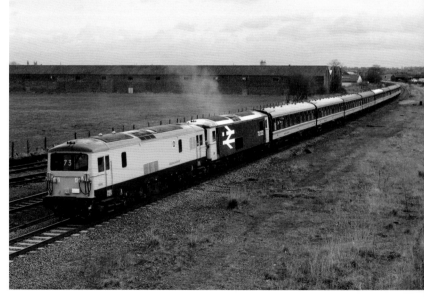

Right: Saltney Ferry & Mold Junction
Former Southern Region class '73' electro-diesel locomotives Nos 73006 and 73002 were moved far from their original SR home in 1993, when they were transferred to Merseyside to serve as engineers and sandite locomotives, based at Birkenhead. These interesting locomotives were built at Eastleigh Works, and they were intended to work over both electrified and non-electrified lines – for which purpose they had 600 hp diesel engines, as well as 1,600 hp electric motors. No. 73006 soon acquired a bright new yellow livery, while No. 73002 retained its BR 'large logo' colour scheme. On 12 March 1994, the pair worked the 8.15 a.m. Regional Railways North West Crewe to Blaenau Ffestiniog 'Jolly JAs' railtour between Chester and Llandudno Junction. They are pictured while hauling the nine-coach train past Mold Junction No. 1 Signal Box, which opened in 1902 and was manned until 2005.

Right: **Sandycroft**

A general view of the station, looking south-east towards Chester during the early 1960s. The platforms here were of wooden construction, with single-storey station buildings on both sides. These timber-framed structures were typical of London & North Western design, being hip-roofed buildings with full-length canopies. These was, in addition, a high-level booking office on the down side – the latter structure, which was of brick construction, being sited on the road overbridge.

Left: **Sandycroft**

From Saltney Ferry, the C&HR route follows a dead-level alignment as trains head north-westwards to Sandycroft (27 miles). This small station was opened on 1 March 1884, and rebuilt when the line was quadrupled in 1900 – the widening being part of an ambitious improvement scheme that was carried out between Chester and Llandudno at the end of the nineteenth century. The track layout consisted of up and down platforms on either side of the running lines, together with a goods yard that was sited to the south-east of the platforms on the up side. A minor road was carried across the railway on a plate girder bridge at the Chester end of the platforms. There were a number of private sidings in the vicinity, one of which served the Chester Electricity Works, while another was used by the International Electrolytic Plant Co. The photograph, dating from around 1910, shows the up side station building.

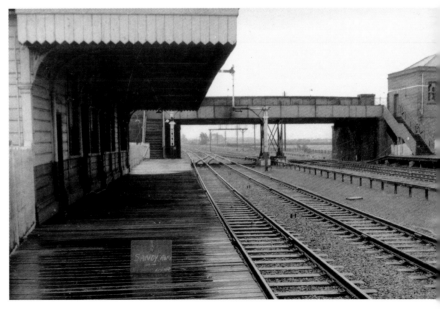

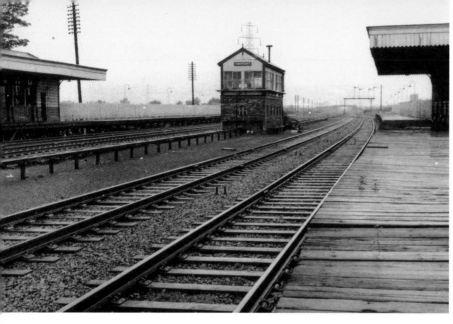

Sandycroft

Above: Another *c.* 1960 view, looking in the opposite direction towards Holyhead. Like the station buildings, the brick-and-timber signal box was a standard North Western structure; it was opened around 1900, and contained a 60-lever frame. Gable-roofed boxes of this same general type were built in large numbers throughout the L&NWR system from 1876 until about 1904, when a modified design was introduced. The '1876'-type cabins had very narrow eaves – the roof being virtually flush with the side walls, giving rise to a distinctly slab-sided appearance.

Below: Class '37' locomotive No. 37417 *Highland Region* passes Sandycroft Signal Box on 31 May 1997 with the 1.22 p.m. Bangor to Crewe North West Regional Railways service. With the transfer of many class '37/4's away from Scotland in the mid-1990s, locomotives with wholly inappropriate Scottish names often appeared on the Chester & Holyhead route.

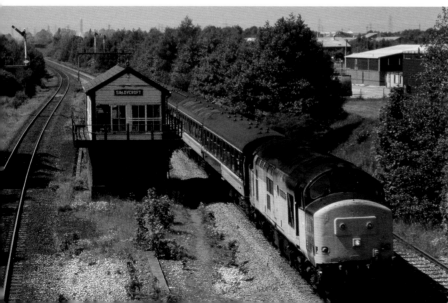

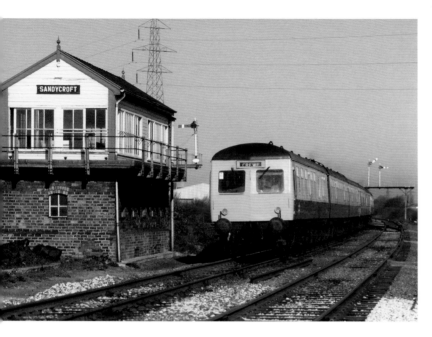

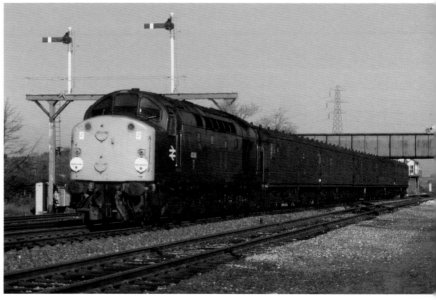

Left: **Sandycroft**

An unidentified class '120' set leads a couple of other units past Sandycroft Signal Box while forming the 7.57 a.m. Llandudno to Crewe service on 24 April 1984. The signal box survived into the new millennium, but was finally demolished in 2005.

Right: **Sandycroft**

Class '40' locomotive No. 40044 passes Sandycroft with a short eastbound parcels train on 24 April 1984. Note the smooth front end – the result of the former nose end connecting doors having been removed. Curiously, this modification had only been carried out on one end of the locomotive – the likeliest explanation being that the engine had suffered minor damage as a result of a derailment that occurred at Chinley in Derbyshire in September 1978.

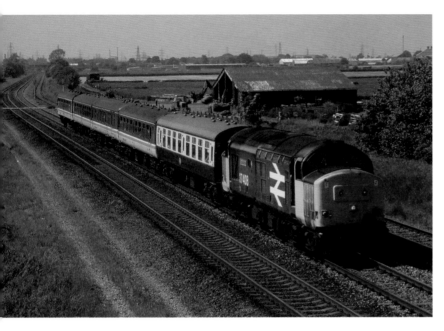

Right: **Sandycroft**

Sister engine No. 37418 *East Lancashire Railway* approaches Sandycroft while hauling the 2.18 p.m. Crewe to Bangor North West Regional Railways service on 31 May 1997. The train is pictured travelling through the virtually flat valley of the River Dee – although as it heads westwards, it will reach progressively hillier terrain.

Left: **Sandycroft**

Class '37' locomotive No. 37408 *Loch Rannoch* passes Sandycroft with the 1.23 p.m. Holyhead to Manchester Piccadilly 'Irish Mancunian' service on 31 May 1997. No. 37408 was the last member of its class to retain the 'large logo' livery; however, to the dismay of many class '37' enthusiasts, the engine was repainted into English Welsh & Scottish Railway red livery a year after this photograph was taken.

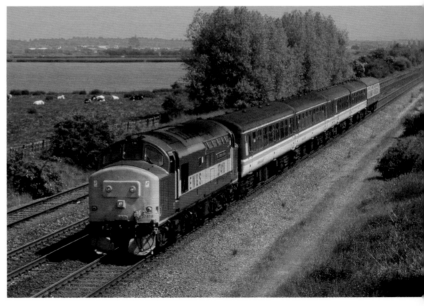

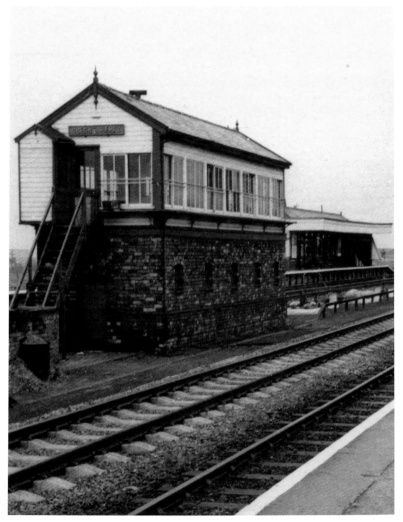

Above: **Queensferry**

On leaving Sandycroft, the Chester & Holyhead route continues north-westwards, and trains soon reach the next stopping place at Queensferry (28¼ miles), which was opened with the line on 1 May 1848 and extensively rebuilt in 1900, when the track layout was quadrupled. The photograph is looking along the down platform towards Holyhead during the 1960s – the signal box being visible to the right – while the goods shed, dating from around 1870, can be seen in the distance.

Right: **Queensferry**

A closer look at the standard L&NWR brick-and-timber signal cabin, which dated from the late Victorian period, and featured the characteristic 'flat-ended' gables favoured by the North Western company prior to around 1904.

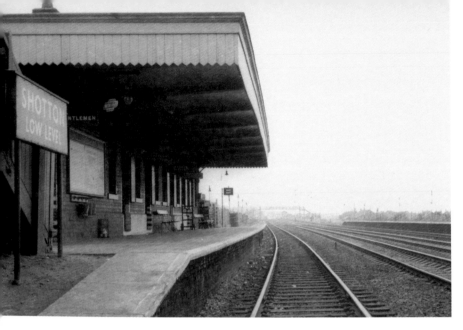

Shotton Low Level

Shotton, the next stopping place (29¼ miles), has a complicated and somewhat checkered history. Although the C&HR route was in operation by 1848, the station was not opened until 1 April 1907. Meanwhile, on 29 June 1883, the Wrexham, Mold & Connah's Quay Railway had obtained parliamentary consent for a line from its original route at Buckley Junction to the River Dee at Shotton. At that point, the WM&CQR would form an end-on junction with a new Manchester, Sheffield & Lincolnshire Railway line to Chester, for which parliamentary consent was obtained on 28 July 1884.

The extension from Buckley Junction to Chester was opened on 31 March 1895, the WM&CQR portion of the new line having stations at Hawarden and 'Connah's Quay & Shotton' – the latter station being laid out at right angles to the Holyhead route. The WM&CQR was absorbed by the MS&LR in 1905, the MS&LR having, in the interim, been renamed 'The Great Central Railway'. Connah's Quay & Shotton station was renamed 'Shotton High Level' after nationalisation, while the main line station became 'Shotton Low Level'. The upper photograph shows Shotton Low Level around 1962, while the lower view shows Shotton High Level during the 1970s.

The Low Level station was closed with effect from 14 February 1966, but a new station was opened on the same site on 21 August 1972. The High and Low Level stations are now regarded as integral parts of a single station – the Chester & Holyhead platforms being Platforms 1 and 2, while the High Level platforms are designated Platforms 3 and 4. The station was refurbished between 2009 and 2010 as part of an improvement scheme that included platform resurfacing, the installation of new waiting shelters and the provision of a new ticket office.

Opposite: Shotton Low Level

Class '37' locomotive No. 37420 *The Scottish Hosteller* is illuminated by a shaft of weak winter sunshine as it passes Shotton Low Level with the 10.07 a.m. Birmingham New Street to Holyhead service on 31 December 1998. The Low Level platforms can be seen in the distance.

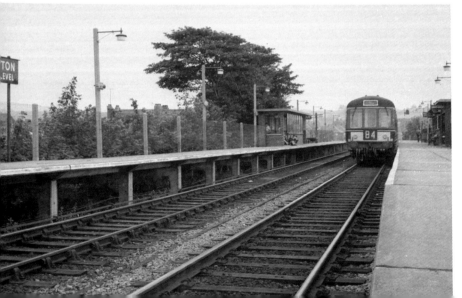

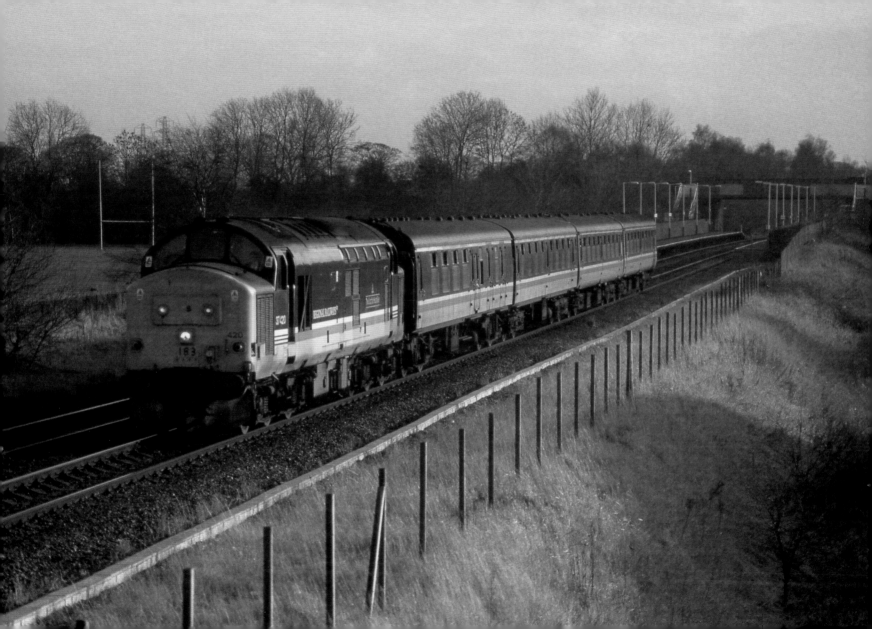

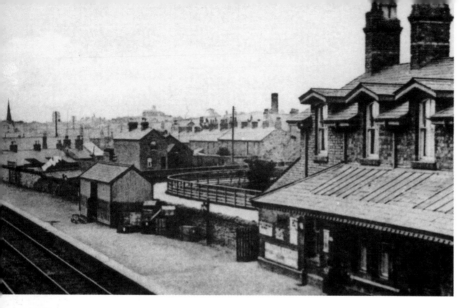

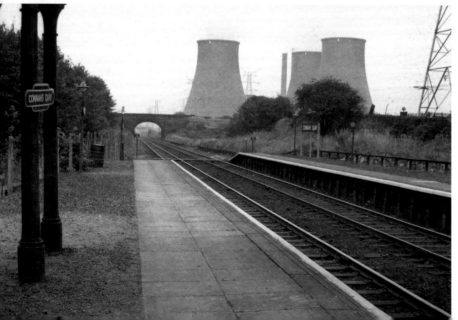

Connah's Quay

From Shotton, the route follows a level alignment towards Connah's Quay (30¼ miles). This station served a predominantly industrial area, and notwithstanding the decline of British manufacturing industry in recent years, the surrounding landscape is still dominated by industry. The station, opened on 1 September 1870, was a two-platform stopping place with its main station building on the down side – the latter structure, shown in this early twentieth-century postcard view, being a two-storey building that incorporated living accommodation for the stationmaster and his family.

The Wrexham, Mold & Connah's Quay main line passed beneath the Chester & Holyhead route at the east end of the station, while a spur from the WM&CQR converged with the Holyhead route at the west end of the platforms. The Wrexham, Mold & Connah's Quay line served a complex of docks and industrial premises along the banks of the Dee, which were also served by another WM&CQR line from Shotton High Level – all of these lines being freight-only routes.

Opposite: Connah's Quay

A general view of Connah's Quay station looking west towards Holyhead during the early 1960s. This station was closed with effect from 14 February 1966.

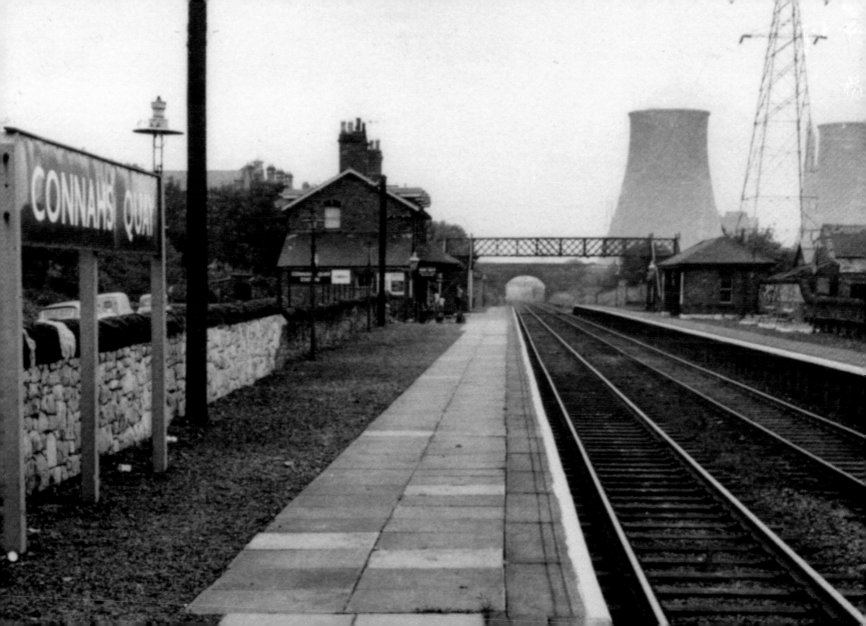

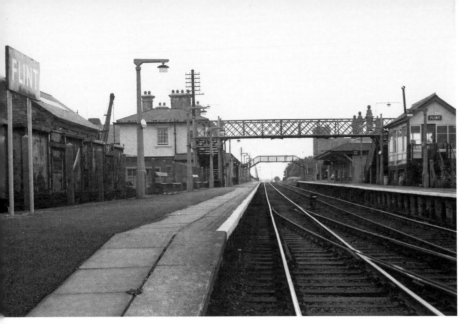

Flint

Having left Connah's Quay, trains continue north-westwards along the Dee Estuary, with distant views of the Wirral Peninsula, on the opposite shore. After passing through the short Rockcliffe Hall Tunnel trains reach Flint (33¼ miles), which was opened by the Chester & Holyhead Railway on 1 May 1848. The main station building, on the down side, was of typical C&HR design, being a substantial, two-storey structure in the Italianate style, with a low-pitched hipped roof and a profusion of chimney stacks. The main block was flanked by single-storey 'pavilions', the space between these two pavilions being roofed-over to create an open-fronted loggia for the benefit of waiting travellers. The rear elevation featured two projecting wings, and these were linked by a section of roof covering at ground-floor level to form another porch or loggia over the main entrance to the building.

The upper picture provides a general view of the station, looking west towards Holyhead during the early 1960s. The main station building can be seen to the left, while the LMS-style signal cabin is sited on the up platform. The now-closed goods yard was situated at the rear of the down platform, and the roof of the goods shed can be glimpsed on the extreme left of the picture; this still-extant structure is now a listed building, together with the main station building. The lower view is looking north-westwards along the down platform. There was, at one time, a level crossing immediately to the west of the platforms, but this was abolished in the 1930s and Castle Street was then severed, although a footbridge was retained for pedestrians.

Opposite: Flint

47207 arrives at Flint station on 28 June 1984 with an unidentified westbound working. The Chester & Holyhead station building features prominently on the right of the picture. It is now a Grade II listed building.

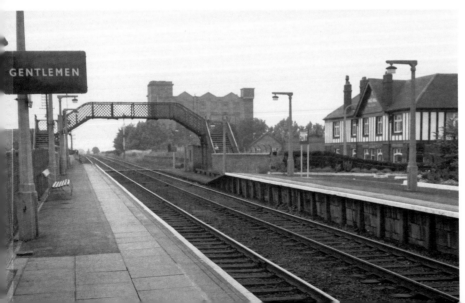

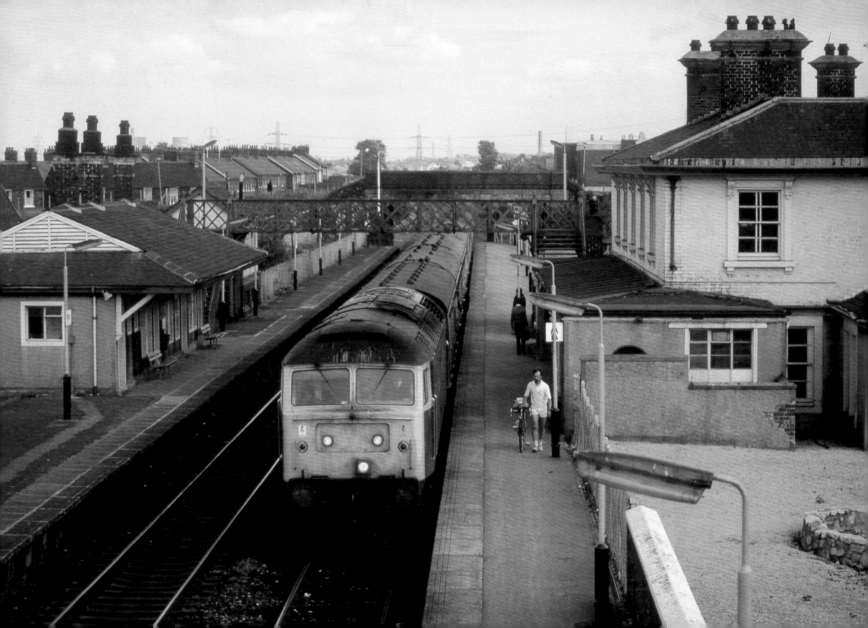

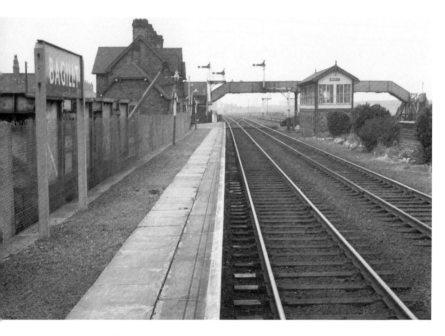

Left: Bagillt

Maintaining its relentless north-westerly heading, the line continues along the side of the estuary to Bagillt (5¾ miles). The track layout here was similar to that at Queensferry, the station having been rebuilt when the line was quadrupled at the end of the nineteenth century. Up and down platforms were provided for stopping services, but there were no platforms on the fast lines that ran through the centre of the station. The main station building, a two-storey Tudor-Gothic style structure, was on the down side, while the up platform was equipped with a single-storey, hip-roofed building with a projecting canopy. The up and down sides were linked by a plate girder footbridge, and the now-defunct goods yard was sited on the down side.

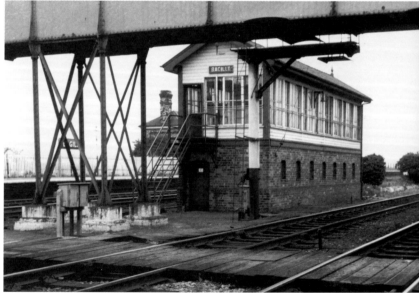

Right: Bagillt – The Signal Cabin

The 72-lever signal cabin, which was opened in 1907, was sited between the up and down fast lines. Like most twentieth-century L&NWR boxes, this standard brick-and-timber structure featured a slate-covered roof that extended well beyond the four walls, the overhang at each end being about 1 foot. Metal steps gave access to the glazed upper storey. 'Reshaping' had a major impact upon the Chester & Holyhead main line during the 1960s, insofar as goods yards were closed and the number of intermediate stations was considerably reduced, while many of the surviving stations became un-staffed halts. Twelve stations, including Bagillt, were closed to passengers and parcels traffic with effect from Monday 14 February 1966 – the other victims being Queensferry, Shotton Low Level, Connah's Quay, Holywell Junction, Mostyn, Talacre, Conwy, Menai Bridge, Llanfair PG, Gaerwen and Valley.

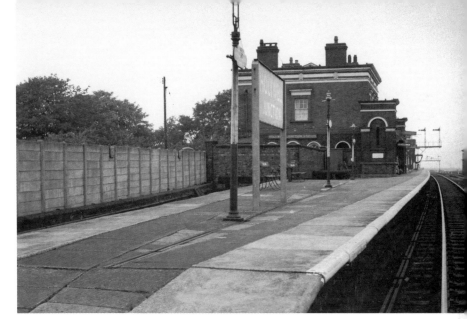

Holywell Junction – The Station Building

Hollywell Junction (38 miles) was opened as 'Hollywell' on 1 May 1848, but its name was changed to 'Holywell Junction' following the opening of the Hollywell Town branch on 1 July 1912. The branch was of considerable interest, insofar as it was built on the trackbed of a former mineral railway. The junction station boasted four platforms for main line traffic, together with a short bay for Holywell Town trains.

The upper picture depicts the main station building, which was on the down side and is now a Grade II listed building. Designed by Francis Thompson, this two-storey structure was of red-brick construction in the Italianate style, with an almost flat, ribbed-slate roof. The platform frontage featured projecting pavilions which were linked by a canopy, while the upper part of the building was graced by a prominent cornice and deep entablature with decorative 'rose' bosses. The ground-floor windows and doorways were boldly arched, whereas the first-floor window openings were square-headed. The lower photograph shows the western end of the platforms, which were linked by an underline subway with covered entrances.

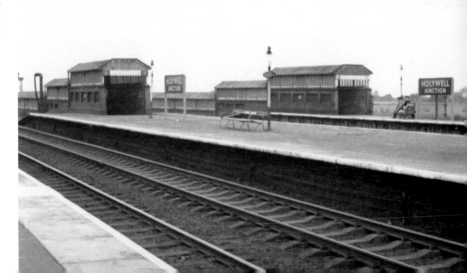

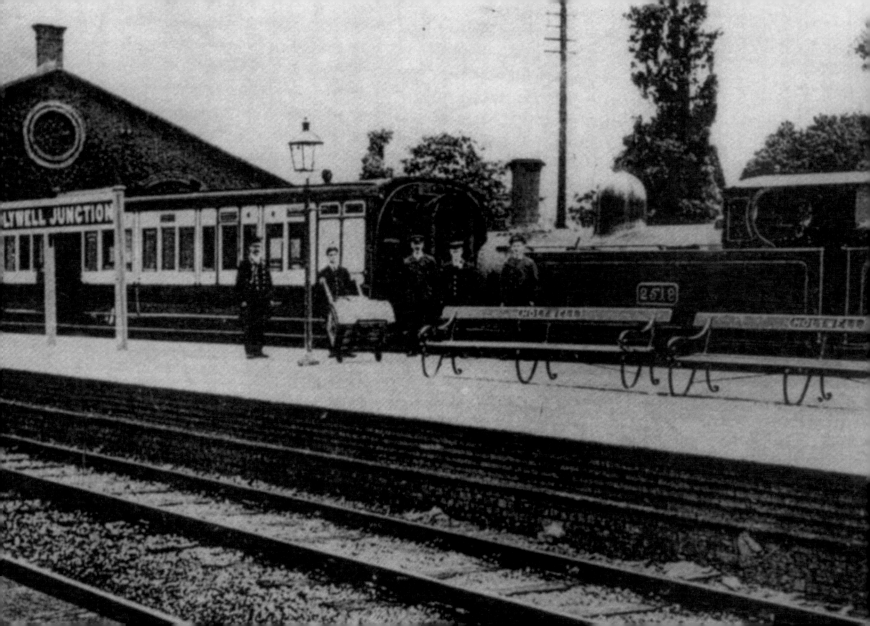

Holywell Junction

Above: The eastern end of the platforms at Holywell Junction, looking towards Chester, with Courtauld's Greenfield factory visible beyond the road overbridge. The Greenfield site encompassed two rayon production facilities known as Greenfield No. 1 and Greenfield No. 2 plants. These mills employed over 2,500 people by the late 1960s. The factory was modernised between 1979 and 1981, and closed in 1985. The factory was rail-connected, and it received regular loads of fuel oil until its closure.

Below: A Holywell Town passenger train stands in the branch line platform around 1951, the locomotive being motor-fitted class Ivatt '2MT' 2-6-2T No. 41276. This engine hauled the last train on the Holywell Town branch on Saturday 4 September 1954. The branch remained in use for freight traffic until 1957, while Holywell Junction was itself closed with effect from 14 February 1966, the station have become a victim of the 1966 closure programme. The station building, a Grade II listed building, has survived as a private dwelling.

Opposite: Holywell Junction

A Holywell Town branch line train stands in the bay platform around 1912, the goods shed being visible to the left. The locomotive is Webb 2-4-2T No. 2518.

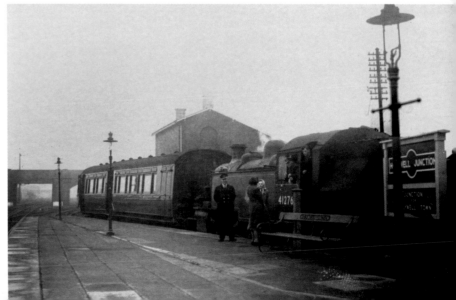

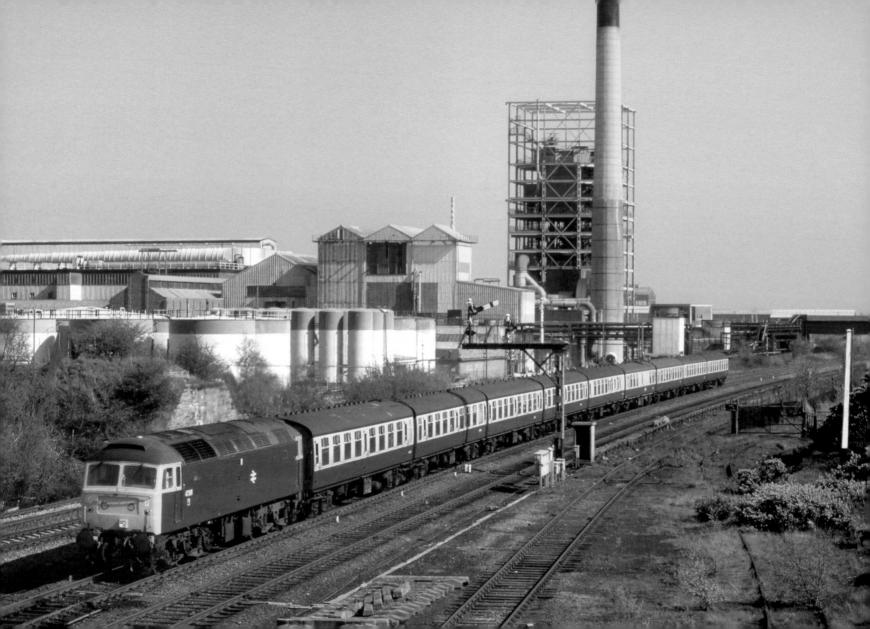

Mostyn

From Holywell Junction the route continues north-westwards to the now-closed station at Mostyn (41¼ miles). When opened on 1 May 1848, Mostyn had been merely a wayside stopping place, but it later developed into a relatively important station with four platforms, a goods yard and a private siding link to the nearby Darwen & Mostyn Iron Works. Quadrupling was completed in 1902, but the original C&HR station building and goods shed remained in use on the down side. An island platform was constructed between the up and down fast lines, and a new side platform was provided for stopping trains on the up side, all four platforms being linked by a plate girder footbridge.

The upper photograph is looking north-westwards along the original down platform, which was used by stopping trains after the line had been quadrupled. The two-storey Italianate station building, designed by Francis Thompson, can be seen to the left. This distinctive structure is of red-brick construction with prominent stone quoins and dressings and an almost flat roof. The platform frontage is flanked by two single-storey pavilions, while the rear elevation features projecting two-storey wings at each end, with ornamental panels between the windows, each bearing a coronet over a cartouche head of Lord Mostyn.

The lower view is looking south-eastwards towards the ironworks during the early 1960s, part of the goods yard (closed in 1964) being visible on the extreme right. Mostyn station was closed with effect from 14 February 1966, but the station building – now Grade II listed – has survived.

Opposite: Holywell Junction

Class '47' locomotive 47598 heads westwards past the now demolished Courtaulds textile plant at Greenfield with the 12.40 p.m. Euston to Holyhead service on 24 April 1984. This location is unrecognisable now, all traces of the factory having been removed, while the site has now been replaced by scrubby silver birches.

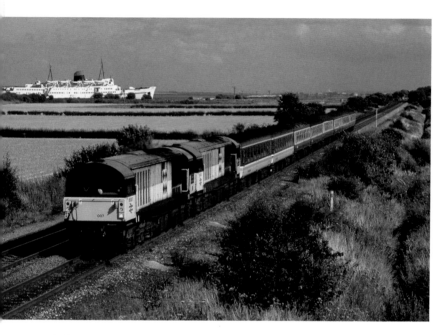

Right: **Mostyn**

Class '25' locomotive No. D7672 *Tamworth Castle* retired from the national network on 30 March 1991, four years after the rest of the class had been withdrawn by BR. The 7.20 a.m. Hertfordshire Railtours' Kings Cross to Holyhead 'Rat Requiem' railtour is pictured passing Mostyn, with the unmistakable outline of the grounded *Duke of Lancaster* in the background. No. D7672 had taken over the train at Leeds – ten coaches being a significant load for the 1,250 hp locomotive. The locomotive is at present on the Churnet Valley Railway (in BR blue livery, with its TOPS number 25322).

Left: **Mostyn**

Class '58' locomotives Nos 58007 *Drakelow Power Station* and 58003 *Markham Colliery* approach Mostyn with the 3.40 p.m. Crewe to Llandudno special during the 'Trainload Coal Motive Power Day' on 11 August 1991. The white ship that can be seen in the distance is the 4,797-ton turbine steamer *Duke of Lancaster* – a former Sealink ferry that was built in Belfast by Harland & Wolff in 1955/56 for service between Heysham and Belfast, although she also worked on the Fishguard to Rosslare route. This vessel was 361 feet overall, with a beam of 55 feet and capacity for 2,000 passengers. She was sold in 1979 and beached at Mostyn for use as a static leisure centre and 'fun ship' but, having given the project every encouragement during its early stages, the local council refused to grant planning permission, and the scheme was abandoned. The *Duke of Lancaster* was left stranded in her sand-filled berth on the shoreline, where she remains to this day.

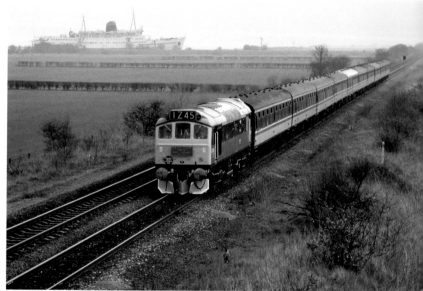

Right: Mostyn

A six-car class '101' multiple unit formation heads south-eastwards past the site of Mostyn station on 21 April 1984, the leading vehicle being motor brake second No. 51188. This vehicle has survived into preservation, and it currently resides on the Ecclesbourne Valley Railway in Derbyshire.

Left: Mostyn

Class '20' locomotive No. 20143 and sister engine No. 20214 pass Mostyn on 11 August 1991, while hauling a Merry-go-Round coal working from Point of Ayr Colliery to Fiddlers Ferry Power Station. Although No. 20214 has survived in preservation on the Lakeside & Haverthwaite Railway, No. 20143 was cut up in 1993 apparently by mistake, as it had also been acquired for preservation. By 1991, the days of class '20's on coal traffic were numbered, and in fact Point of Ayr Colliery survived for a only few more years, its closure in 1996 marking the end of deep pit mining in North Wales.

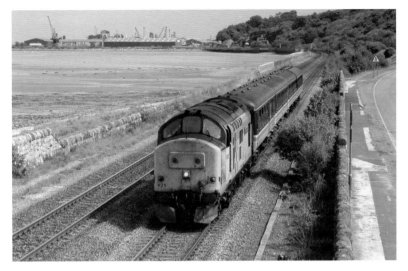

Mostyn

Left: Class '37' locomotive No. 37425 *Sir Robert McAlpine/Concrete Bob* passes Ffynnongroyw, to the west of Mostyn station, with the 2.24 p.m. Crewe to Bangor Regional Railways service on 20 May 1995. The buildings and cranes at Mostyn Dock can be seen in the background.

Below left: Class '45' locomotive No. 45115 speeds through Mostyn with a down passenger working from Scarborough to Bangor on 24 April 1984; No. 45115 was withdrawn in June 1988 and scrapped around two years later.

Below right: A six-car multiple unit formation heads southwards through Mostyn on 26 August 1983, with an unidentified Metro-Cammell class '101' twin set leading. The working is unidentified, but it may have been the 4.00 p.m. Llandudno to Manchester Victoria service. The slightly misty day almost hides the view of the Dee estuary in the background.

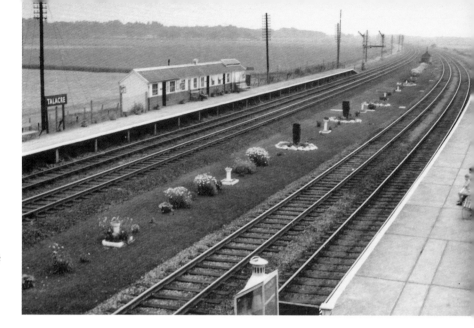

Talacre

Talacre, the next station, was 44¼ miles from Crewe. It was not one of the original stopping places, having been opened by the L&NWR on 1 May 1903. Although the station was situated on a quadruple-track section, there were no platforms for main line traffic – the up and down platforms being sited on either side of the slow lines as shown in the accompanying photographs, which are both looking westwards from the road overbridge. The platforms were of timber trestle construction, while the wooden station buildings were simple, single-storey structures of typical North Western design. The gable-roofed signal cabin, which was sited to the east of the platforms on the up side, was a brick-and-timber cabin of the usual L&NWR type, with a 24-lever frame.

The 1938 *Railway Clearing House Handbook of Stations* reveals that Talacre could deal with coal, livestock and general merchandise traffic, the modest goods yard being to the east of the road bridge on the down side. A private siding served the Point of Ayr Colliery, which remained in operation until 1996. Sadly, Talacre station had a relatively short life; the goods yard was closed in May 1964 and passenger services were withdrawn with effect from Monday 14 February 1966.

Overleaf: Talacre

Class '47' locomotive No. 47201 passes the abandoned platforms at Talacre station while working the 2.40 p.m. Llandudno to Manchester Victoria service on 16 June 1985.

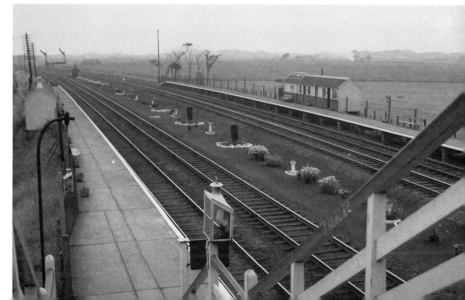

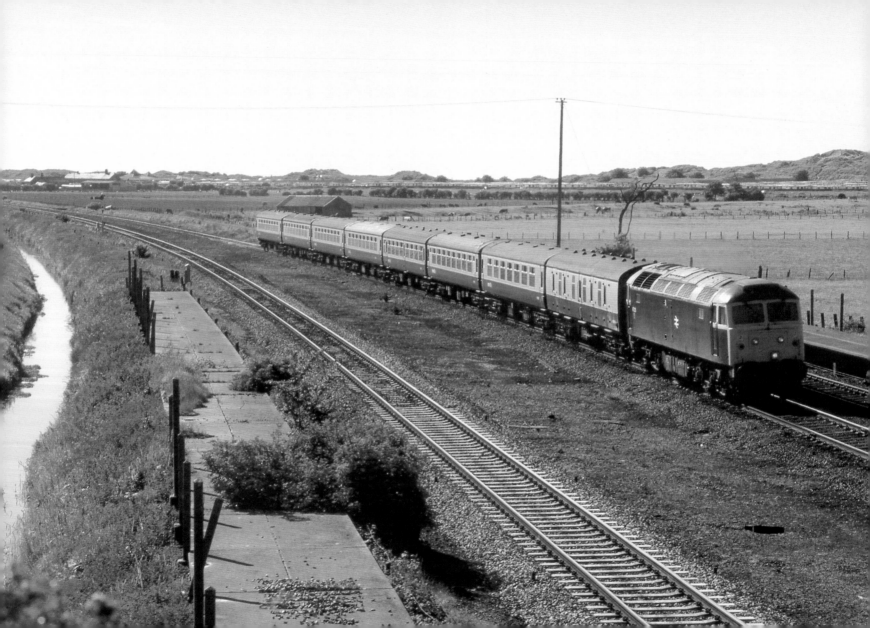

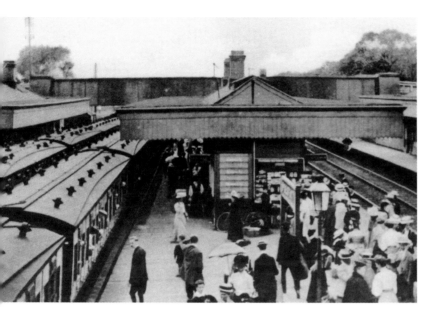

Left: **Prestatyn**

Having rounded the headland at Point of Ayr, the railway finally leaves the Dee Estuary and, as trains head south-westwards along the North Wales coastline, the open sea can be seen to the right. Prestatyn (47¾ miles) was originally no more than a fishing village, but the opening of the railway in 1848 enabled this hitherto remote place to develop as a seaside watering place – initially for middle-class visitors, but later as a place of resort for the working classes. Traffic built up to such an extent that, on 28 February 1897, a much enlarged station was opened on a new site to the west of the original stopping place, the C&HR station building being left in situ near the goods yard on the down side. On 22 September 1900, the *North Wales Chronicle* reported that the recently completed station had replaced an 'antiquated station which was certainly the most dangerous on the line'. This postcard view provides a glimpse of the new station during the early 1900s, its platforms thronged with summer visitors.

Right: **Prestatyn**

This later view, dating from the 1960s, is looking westwards along Platform 1. The platform on the right of the picture became an island when the line was quadrupled. Prestatyn was the starting point for the Dyserth branch, which was opened for goods traffic on 1 September 1869, and for the carriage of passengers on 26 August 1905. The branch was just 2 miles 65 chains in length, and it left the main line by means of a connection at the west end of Prestatyn station. As the junction faced towards Holyhead, branch trains had to reverse out of the station as far as Prestatyn No. 1 Signal Box, at which point they changed direction for the run along the branch to Dyserth – a similar operation being necessary in the reverse direction. The line was worked by steam railmotors or push-pull workings until the withdrawal of passenger services in September 1930, although freight trains continued to run until 1973.

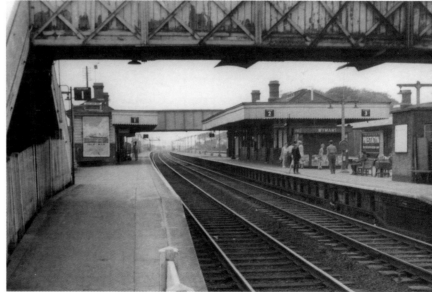

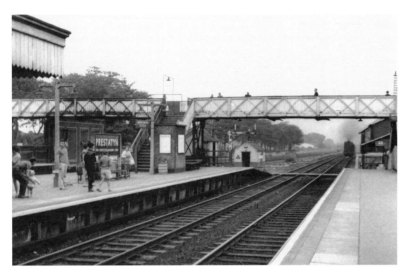

Prestatyn

Left: Looking eastwards during the early 1960s. The original 1848 station was sited just beyond the lattice girder footbridge, and the old station building can be seen in the distance.

Below left: Class '56' locomotive No. 56071 passes Prestatyn with the 1.00 p.m. Llandudno to Crewe special on 20 May 1995. This was one of a number of special trains organised by the Crewe Rail Events Committee, and billed as the 'North Wales Coast Motive Power Day'.

Below right: This final view of the station is looking east towards Chester, probably around 1930. Prestatyn station remains in operation and, according to figures published by the Office of Rail Regulation, it now generates approximately 300,000 passenger journeys per annum. The infrastructure has nevertheless been reduced, and all trains now use the central island platform – the outermost platforms having been abandoned. The station has recently acquired a new footbridge which, in compliance with present-day legislation, has gently sloping approach ramps of enormous length, for the benefit of wheelchair users.

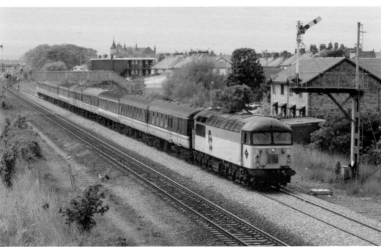

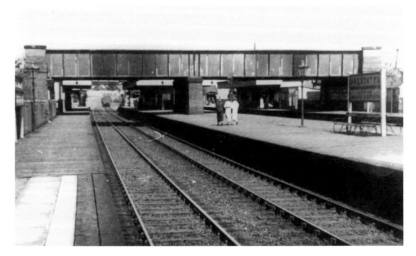

Rhyl – The Old & New Stations

Leaving Prestatyn, trains head west-south-westwards along the coast towards Rhyl (51¼ miles), this section of the route being remarkable for the large number of caravan sites, which have spread inexorably along the seashore on both sides of the line.

The history of Rhyl station echoes that of Prestatyn. The station originated in 1848 as a minor stopping place serving a tiny fishing village 'with a few straggling houses'. However, the opening of the railway transformed this rural location into a thriving seaside resort, and by the end of the Victorian period, Rhyl had developed into 'a sort of Midlands Margate, with all the attractions of that popular holiday haunt'. In the words of the 1907 *Little Guide to North Wales*, this popular 'sea-air resort' possessed 'a good pier, a fine promenade and marine drive ... good hotels, fine streets, and an abundance of boarding houses'.

The rapid development of the town during the Victorian period resulted in a vast upsurge in traffic and, following complaints from local traders and residents, the L&NWR decided that a much larger station would be provided. On 11 February 1899, the *North Wales Chronicle* announced that the original down platform would be removed in its entirety to facilitate the quadrupling of the line. 'New waiting rooms, booking offices and refreshment rooms' would be erected on the new down platform, while additional by-pass lines would be laid on the south side of the station. New bay platforms would be available for branch line traffic, and 'a new passenger and luggage bridge' with hydraulic lifts would be constructed. Other new facilities would include new cattle loading pens, sidings and a large carriage shed. The work, carried out by Messrs Gates & Thomas of Warrington, was accomplished in about eighteen months at a cost of £200,000.

The upper picture shows the up platform around 1912, with the main station building to the right. The lower view shows the commodious bay platforms that were provided for branch line services at the west end of the new down platform.

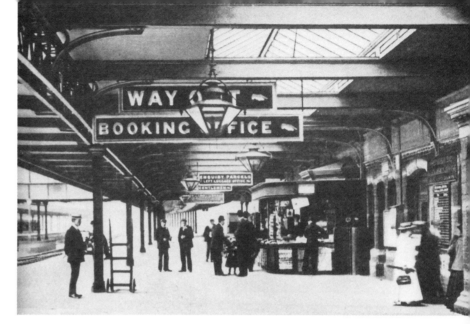

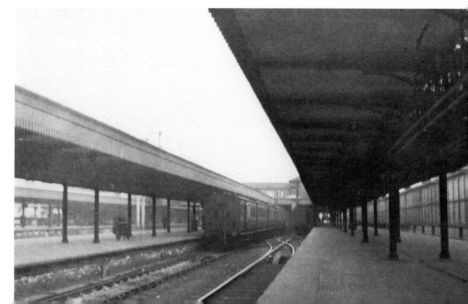

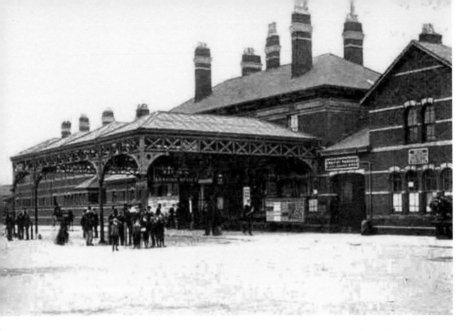

Rhyl – The Main Station Buildings

When opened on 1 May 1848, Rhyl had featured one of Francis Thompson's distinctive two-storey station buildings, but the appearance of this early Victorian building was utterly transformed as part of the reconstruction scheme. The remodelled building was much longer, with an enormous porte-cochère, as depicted in the upper photograph.

The original building, which can be seen behind the *porte-cochère*, is of brown-brick construction with yellow-brick banded dressings and an ashlar cornice; the roof profile was altered when the building was enlarged. The extensions on either side of the main block were added during the rebuilding – that on the right (when viewed from the platform) is longer than its counterpart on the left-hand side, and incorporates a two-storey booking office and waiting room block.

The platform frontage was covered by extensive canopies, which have remained in place, although the ornate *porte-cochère* at the rear of the building has not survived.

The lower view is looking eastwards along the up platform and the four-road carriage shed is just about visible beyond the road overbridge.

Opposite: Rhyl 'The Welsh Dragon'

Ivatt class '2MT' 2-6-4T No. 41320 stands in Rhyl station with the 'Welsh Dragon' – a popular summer-only push-pull service that ran between Rhyl and Llandudno and was introduced in July 1950. The train ran on Mondays to Fridays only, and journey times for the 17¼-mile journey varied between 31 and 39 minutes, with stops at Old Colwyn and Colwyn Bay. The headboard depicted a red dragon on a green shield, above the words 'The Welsh Dragon' in yellow letters on a red ground. The Welsh Dragon must have been one of the very few push-pull services to have been graced by such a title, while the journey of 17¼ miles was probably the shortest distance ever covered by a named train on a main line railway!

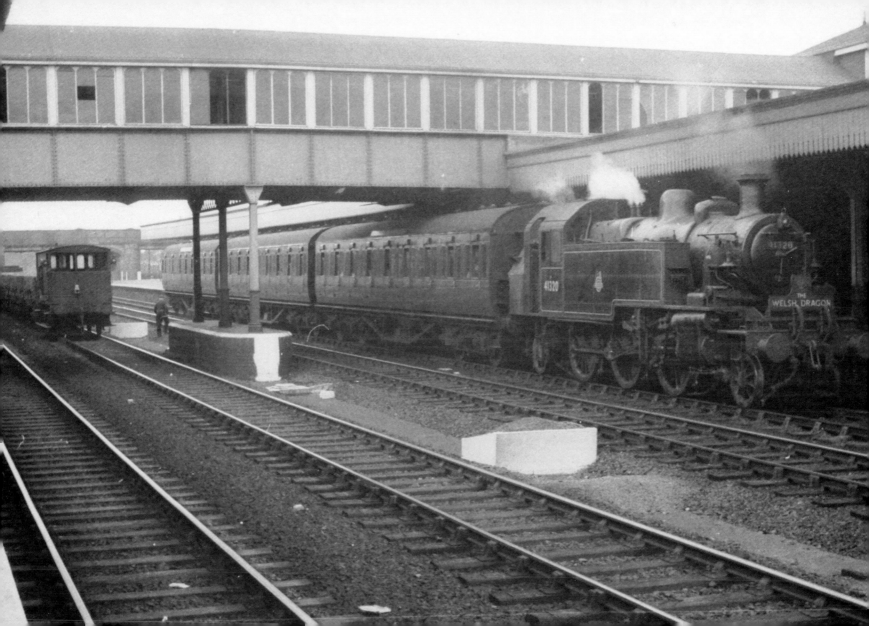

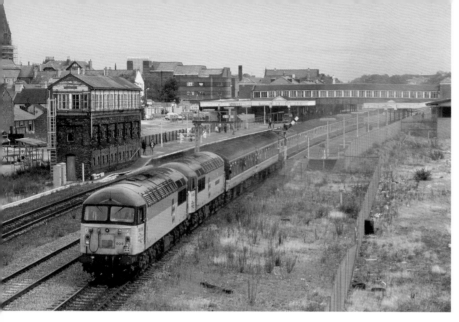

Rhyl

Above: Class '56' locomotives Nos 56009 and 56028 *West Burton Power Station* head westwards through Rhyl with the 3.35 p.m. Crewe to Llandudno special on 11 August 1991. This enthusiasts' special was one of a series of special trains hauled by freight locomotives during 'Trainload Coal Motive Power Day'. The station was signalled from two standard L&NWR brick-and-timber signal cabins, which were opened in 1900 and designated Rhyl No. 1 and Rhyl No. 2 boxes. The former No. 1 Box – at the east end of the station – contained a 90-lever frame, while the No. 2 Box, which can be seen in the photograph, was slightly larger, with 126 levers. It was closed in March 1990 but, as it had been designated a Grade II listed building, the redundant building could not be demolished.

The abandoned bay platforms on the right-hand side of the picture were used by services on the Vale of Clwyd Railway, which was opened between Rhyl and Denbigh on 5 October 1858. The route was extended southwards to Ruthin by the Denbigh, Ruthin & Corwen Railway on 1 March 1862, while on 6 October 1864 the line was completed throughout to Corwen, where connection was made with the Great Western cross-country route from Ruabon to Dolgelly.

Below: Class '37' locomotive No. 37417 *Highland Region* departs from Rhyl in a torrential downpour as it hauls the 12.18 p.m. Crewe to Bangor Regional Railways service on 26 August 1996. The now disused No. 2 Box can be seen to the left, while redevelopment has obviously taken place on former railway land to the right of the picture.

Opposite: Rhyl

Class '45' locomotive No. D172 *Ixion* pulls out of Rhyl station with the 7.10 a.m. Pathfinder Tours Swindon to Holyhead 'North Wales Coast Explorer' railtour on 26 August 1996.

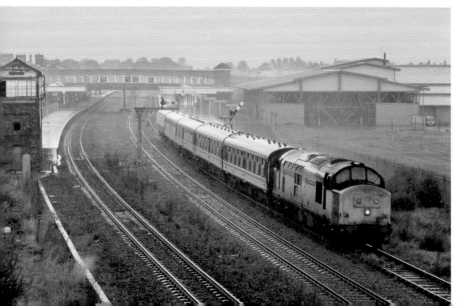

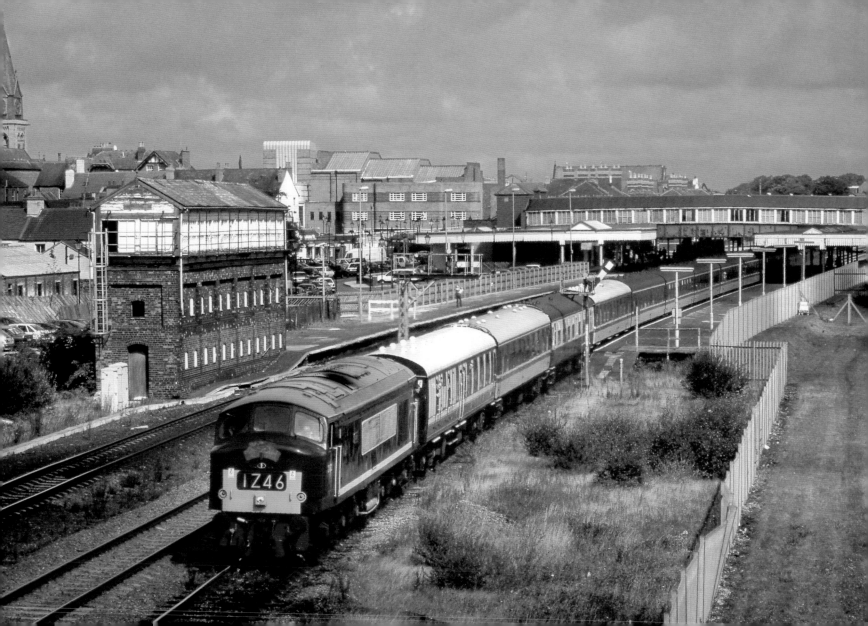

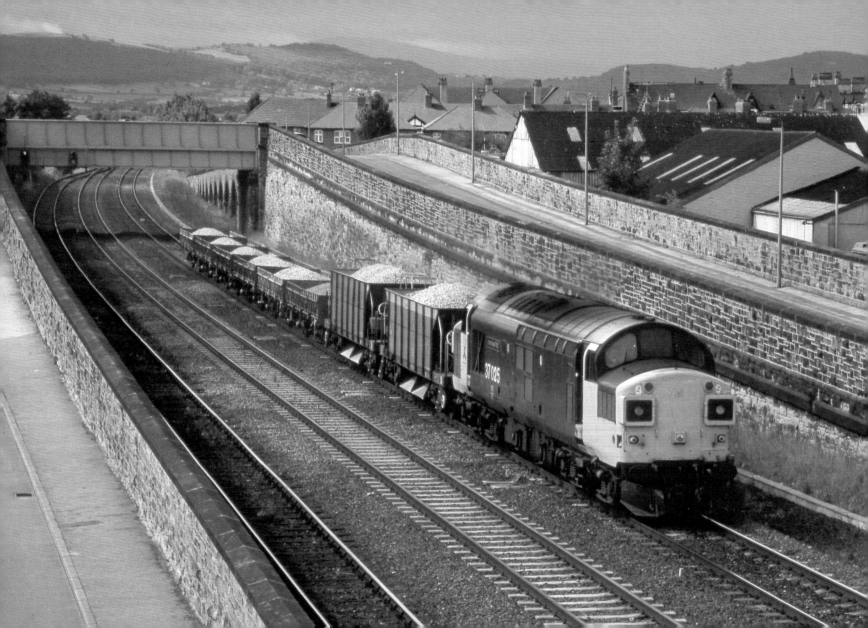

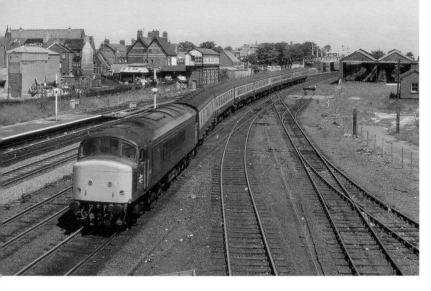

Left: **Rhyl**

Class '45' locomotive No. 45142 arrives at Rhyl with the 8.20 a.m. Newcastle to Llandudno service on 19 June 1985. Rhyl No. 1 Signal Box can be seen in the left distance, while the former carriage shed is visible to the right of the picture. In addition to its carriage shed, Rhyl was also the site of an engine shed – this three-road structure being sited to the west of the platforms on the up side. In 1959, the shed, which was then coded '6K', housed fourteen locomotives, including Ivatt class '2MT' 2-6-2Ts No. 412176 and 41276, class '2P' 4-4-0 No. 40589, Ivatt class '2MT' 2-6-0 No. 46445, and BR Standard class '2MT' 2-6-0 No. 78038. There were also a number of '2F', '3F' and '4F' 0-6-0 goods and shunting locomotives, among them veteran ex-Lancashire & Yorkshire 0-6-0s Nos 52119 and 52162.

Right: **Rhyl**

Class '37' locomotive No. 37428 passes Kinmel Bay, on the western outskirts of Rhyl, with the 2.15 p.m. Crewe to Holyhead service on 19 June 2000. The town of Rhyl can be seen in the background. No. 37428 had started the new decade at work in Scotland, but had spent the summer on the North Wales coast before returning to Scotland for a few weeks, and ending the year back in Wales!

Opposite: **Rhyl**

Class '37' locomotive No. 37025 *Inverness TMD* finds a little patch of weak sunshine amid the dark clouds as it enters Rhyl with the eastbound 11.03 a.m. Penmaenmawr to Warrington Arpley ballast train on 26 August 1996. The engine is wearing a kind of intermediate livery, based on the large logo colour scheme, although clearly it has no BR logos at all. Otherwise, the extended yellow warning panels around the cabs with black window surrounds and larger numbers is the same format as the large logo livery. The train is passing through a walled cutting which is spanned by a skew-girder bridge known as the 'H' Bridge because of its plan. No. 37025 was withdrawn in 1999, but the locomotive has since found a home at the Bo'ness & Kinneil Railway.

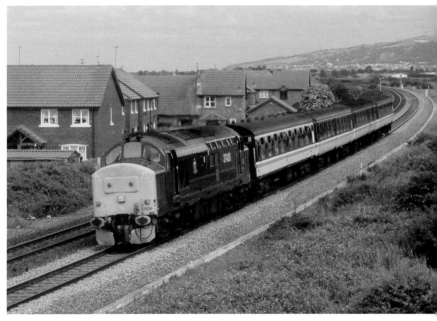

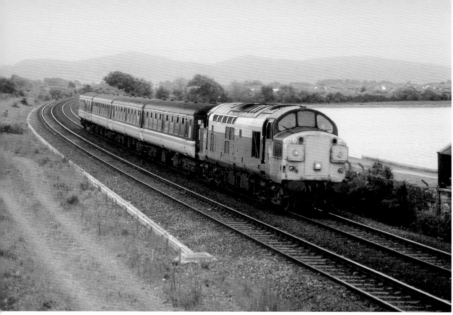

Rhyl – Foryd Junction

Leaving Rhyl, down services pass the Marine Lake and, with the Rhyl Miniature Railway running alongside, the Holyhead route approaches the River Clwyd, which is crossed by means of a long, low, girder bridge. Beyond, the line formerly bifurcated at Foryd Junction, with the Vale of Clwyd Railway heading southwards, while the main line continued more or less due west. A goods-only branch left the Vale of Clwyd line about ¼ mile to the south of the junction and, having passed beneath the Holyhead route, it ran northwards to reach Rhyl Harbour. The infrastructure here included a station at Foryd (52½ miles), which was closed in January 1931, although a halt known as 'Kinmel Bay' was in use on the same site from July 1938 until September 1939.

The upper view shows an unidentified class '37' locomotive passing the Marine Lake with the 8.36 a.m. Holyhead to Birmingham New Street service on 29 May 1999. The lower photograph is looking east towards Rhyl – the Clwyd Bridge being visible in the distance, while the Vale of Clwyd line diverges to the right. The line from Rhyl to Denbigh was closed with effect from 19 September 1955, although summer tourist trains continued to run over the line until the autumn of 1961.

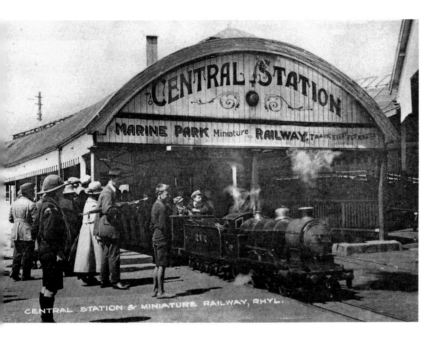

Left: **Rhyl – The Miniature Railway**

The 15-inch gauge Rhyl Miniature Railway is one of the oldest of its kind in the world, having been laid out by the engineer and writer Henry Greenly (1876–1947), and opened on 1 May 1911. The track layout consisted of an irregular circuit, about 1 mile in length, around Rhyl's artificially created Marine Lake, with a station on the north side. The line was acquired by Rhyl Amusements Ltd in 1912 and, thereafter, the railway remained in operation until 1969. After many vicissitudes, the RMR line was reconstructed by Alan Keef of Cote, near Bampton, and in 2001 this pioneering miniature railway was taken over by the Rhyl Steam Preservation Trust – a registered charity, which has continued to operate the railway until the present day. The photograph shows a train in the original 'Central Station', the locomotive being a Greenly-designed 'Little Giant' 4-4-2.

Right: **Rhyl – The Miniature Railway**

The Rhyl Miniature Railway was originally worked by two standard Bassett-Lowke 'Little Giant' class 4-4-2 locomotives named *Prince Edward of Wales* and *George the Fifth*, but these were later replaced by four Greenly-designed 'Albion' class 4-4-2s, which were built in Rhyl during the early 1920s by Albert Barnes, the line's manager, who was also the proprietor of a local engineering firm. They were named *Joan*, *John*, *Michael* and *Billie*, after the children of Mr Butler, the owner of Rhyl Amusements, and numbered 101, 103, 105 and 106 respectively. The photograph shows No. 101 *Joan*, probably around 1925; this locomotive, which is still at work on the RMR, has 4¼ inch by 7 inch cylinders, and an overall length of 17 feet 5¼ inches.

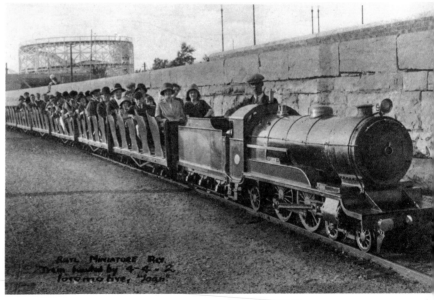

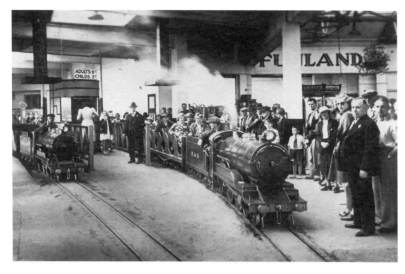

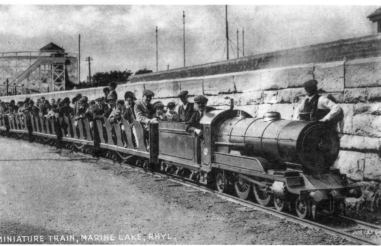

MINIATURE TRAIN, MARINE LAKE, RHYL.

Rhyl – The Miniature Railway

Left: The Central station was rebuilt in concrete during the 1930s. Trains ran around the lake in a clockwise direction, a mode of operation that persists to this day – although the station shown in this *c.* 1935 interior view has been replaced by a new, fully enclosed station at the north-eastern extremity of the circuit. There are three loop lines within the present-day station, together with a siding that leads to the workshop, and an external loop on the north side of the train shed.

Below left: This 1920s postcard shows one of the 'Albion' class 4-4-2Ts (probably *Michael*) with five of the railway's distinctive passenger vehicles, which have curious 'swept-back' seats.

Below right: Another 'Albion' class 4-4-2 stands in the station on 13 June 1935. Three of these locomotives can be seen on the RMR at the time of writing, together with a number of other interesting locomotives.

Opposite: Abergele & Pensarn

Class '37' locomotive No. 37402 *Bont Y Bermo* passes Abergele with the 7.37 a.m. Holyhead to Crewe service on 15 June 1996.

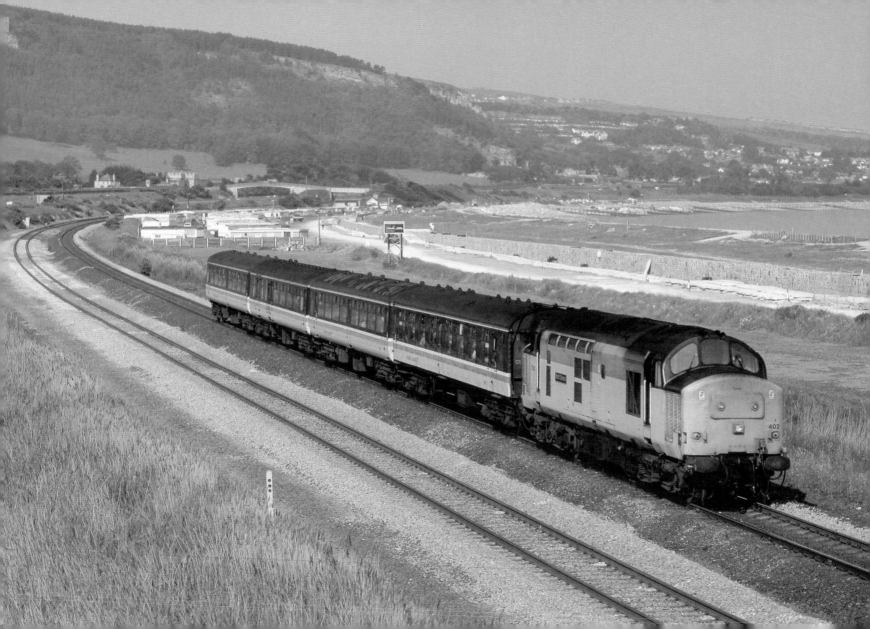

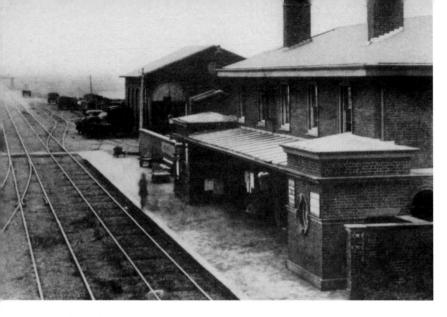

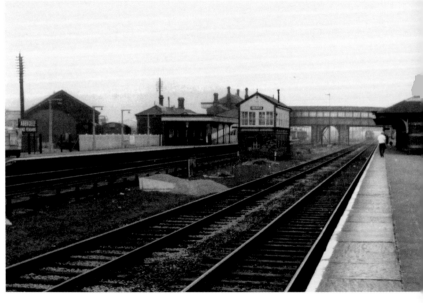

Left: Abergele & Pensarn – The Old Station

Heading west-south-westwards along a dead-level section of track, down trains reach Abergele & Pensarn (55½ miles), which was opened on 1 May 1848 as one of the original stopping places on the C&HR route. The photograph, dating from around 1900, is looking east towards Chester, with the station building and goods shed to the right and the staggered up platform to the left of the picture. Radical alterations were put into effect when the line was quadrupled in 1902. Most of the original Victorian infrastructure was swept away, while a new road overbridge was built across all four running lines. At the same time, the old station building was reconstructed, with a new road-level entrance at first-floor level; access to the platforms was by means of a fully enclosed footbridge and long, sloping ramps.

Right: Abergele & Pensarn – The New Station

This panoramic view of the remodelled station is looking west towards Holyhead around 1964. The above-mentioned covered footbridge is visible behind the standard L&NWR signal cabin, while the goods yard can be seen to the left. Additional goods sidings served the cattle loading pens, which were sited to the west of the road bridge on the down side of the running lines. The signal box was opened in 1902 in connection with the improvements that were being put into effect at that time and it had a 60-lever frame. The extra wide gap between the up and down fast lines suggests that provision had been made for an island platform if traffic requirements had justified such a facility. Camping coaches were stationed at this seaside location for many years.

Opposite: Abergele & Pensarn

Class '31' locomotive No. 31439 *North Yorkshire Moors Railway* and un-named sister engine No. 31465 slow down for their next stop at Abergele while working the 7.39 a.m. Holyhead to Crewe service on 9 August 1995. The sight of a pair of locomotives in Regional Railways' livery, with matching coaching stock, although not unusual, was certainly a bonus on such a bright and sunny morning.

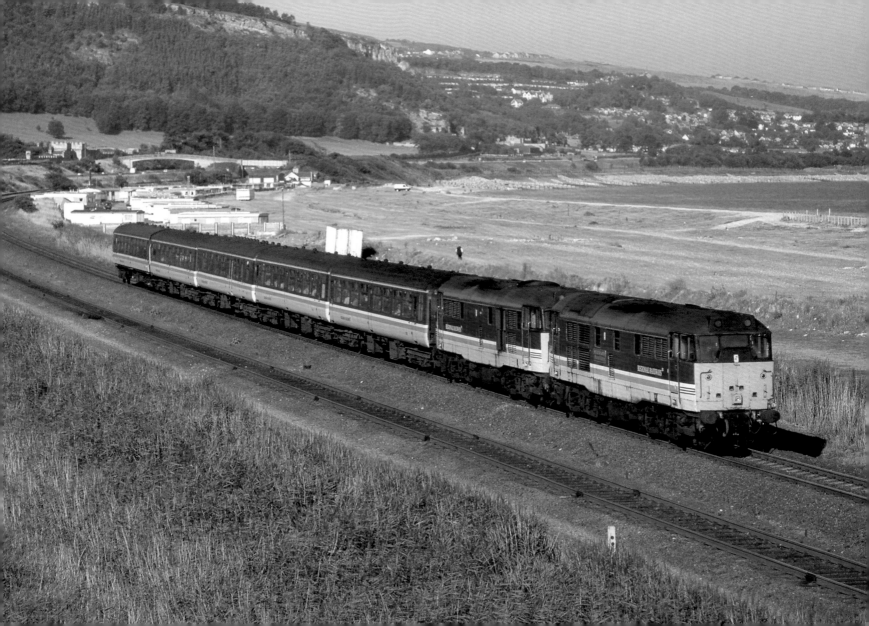

Right: Abergele & Pensarn

Class '56' locomotives Nos. 60061 *Alexander Graham Bell* and 60044 *Ailsa Craig* pass Abergele while hauling the 2.30 p.m. Crewe to Llandudno special on 11 August 1991. This working was one of a number of trains operating over the Chester & Holyhead route with Railfreight traction during the Trainload Coal Motive Power Day. The distinctive upper quadrant signals in the foreground add atmosphere to the picture, although the typical North Wales seaside caravans on the extreme right are rather less photogenic.

Left: Abergele & Pensarn

In appropriately funereal weather, class '25' locomotive No. D7672 *Tamworth Castle* passes through Abergele with the 3.02 p.m. Hertfordshire Railtours Holyhead to Kings Cross 'Rat Requiem' railtour on 30 March 1991. As mentioned on page 41, this enthusiasts' special was arranged to commemorate the retirement of the last class '25' in BR service. A wreath was added to the front end of the locomotive for the homeward run, together with two headboards that read: 'The Rat Requiem Final Journey D7672 30-3-1991' and 'Premier Depot Holbeck 55A.'

Abergele – The 1868 Train Crash

On 20 August 1868, the Irish Mail was involved in a serious accident near Abergele. The Mail, headed by a 2-2-2 locomotive, had left Chester at 11.47 a.m. and passed through Abergele at 12.39 p.m. Meanwhile, at nearby Llandulas, a pick-up goods train was carrying out shunting operations, and the rear vehicles of the train, consisting of six wagons and a brake van, had been left standing on the down main line while three timber wagons were fly-shunted out of a siding. Unfortunately, a junior brakeman lost control of the timber wagons, with the result that they crashed into the stationary rear portion of the train, causing all nine vehicles to roll back down the 1 in 147 gradient towards the oncoming Mail. The inevitable collision took place about 1¾ miles to the west of Abergele, the destruction being intensified by the fact that two of the runaway wagons were loaded with 7¾ tons of paraffin oil in fifty casks. The bursting paraffin casks were ignited by burning coal from the engine, and the first four vehicles of the Mail were rapidly enveloped in a sheet of flames.

The passengers in the front coaches were said to have been killed instantly – witnesses claimed that 'no hand was put out for aid from any of the carriages, nor was a scream heard', the inference being that the victims were already unconscious from the effects of the fumes. Workmen from a nearby quarry, assisted by passers-by and passengers from the undamaged rear portion of the train, formed a chain of buckets across the beach and attempted to fight the flames with seawater, but nothing could subdue the fierce oil-fuelled fire. In its initial report, *The Times* claimed that '23 passengers for Ireland were all burnt so badly that none could be recognised', but in the event it was later ascertained that thirty-three people had been killed.

The upper picture shows the scene of the accident, looking towards Chester, while the lower view depicts the burial of the victims, who were interred in a mass grave in Abergele churchyard.

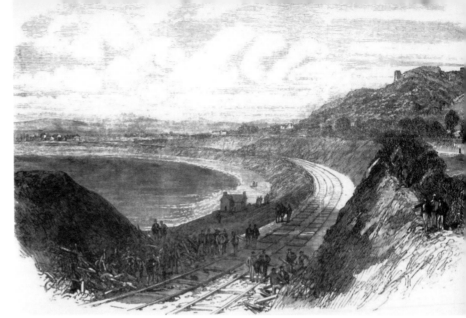

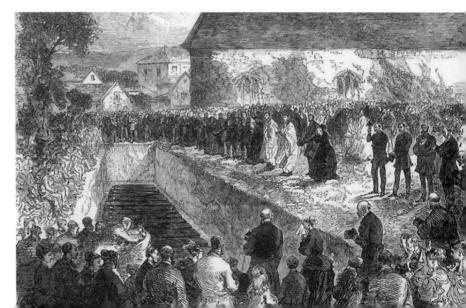

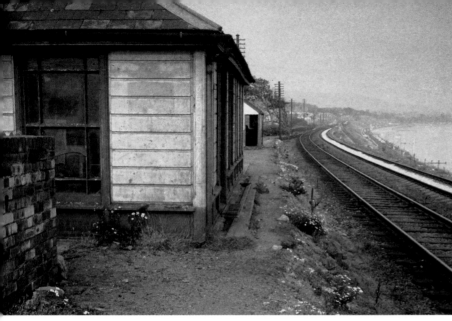

Old Colwyn

Above: Heading westwards from Abergele, down trains are faced with 4 miles of gently rising gradients, mostly at 1 in 333 and 1 in 391, although there is also a stretch of 1 in 100 on the approaches to Penmaenrhos Tunnel. There are three closed stations on this section of the line – at Llandulas (58 miles), Llysfaen (59 miles), and Old Colwyn (60¼ miles). Llysfaen was closed in 1932, while Llandulas and Old Colwyn remained in operation until 1952. The upper picture, which was taken about ten years after closure, shows the abandoned down platform at Old Colwyn. This seafront station was situated on an embankment, its main station building being at ground level on the up side, while the staggered up and down platforms were linked by an underline subway. The wooden structure in the foreground was a waiting room.

Below: A further view of the down platform after closure, looking east towards Chester. The diminutive structure in the foreground was the signal cabin, which contained only 6 levers, and was closed in May 1965.

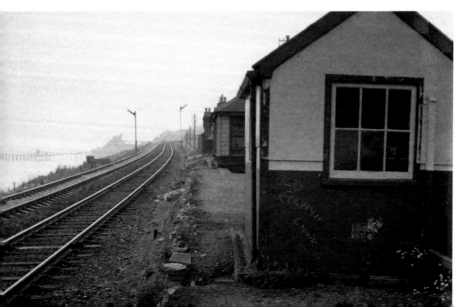

Colwyn Bay

From Old Colwyn, trains continue westwards along the coast to the next station at Colwyn Bay (61½ miles) – a comparatively modern seaside resort that grew up between the villages of Old Colwyn and Llandrillo-yn-Rhos. This new resort was developed largely through the activities of the Pwllycrochan Estate Co., which transformed the park into a fashionable 'watering place'. On 3 August 1872, the *North Wales Chronicle* reported that 'the delightful neighbourhood of Colwyn' was 'becoming more popular as a summer resort for visitors every year'.

A large number of well-built houses and villas had 'sprung up in the last few years', while the Colwyn Bay Hotel, which was nearing completion, would be 'one of the finest in Wales'. By 1901, the growing resort had a population of 8,689, rising to 23,090 by 1961.

The station, originally known as 'Colwyn', was renamed Colwyn Bay in 1876, and reconstructed in 1881 to cater for increasing traffic. A further enlargement took place during the early 1900s when the line was quadrupled, while the platforms were extended in 1910. The upper picture shows the station before its enlargement, while the lower view, dating from the 1960s, illustrates the transformation that took place as a result of the quadrupling. Both views are looking west towards Holyhead.

There were two standard North Western signal boxes, while the goods yard, with provision for coal, livestock, vehicles, furniture, horseboxes and general merchandise traffic, was sited on a low level site to the south-east of the platforms on the down side – access from the running lines being by means of a short, single-track tunnel beneath Victoria Avenue. The goods yard was closed in 1964.

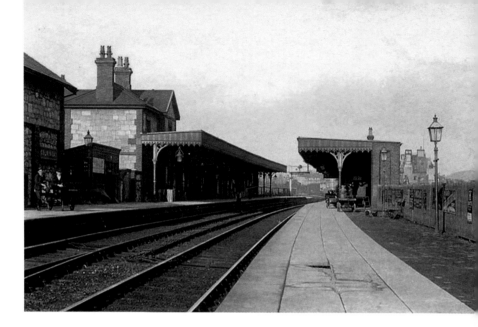

Right: Colwyn Bay
Class '5P5F' 4-6-0 No. 5130 at Colwyn Bay in 1938. The ubiquitous 'Black Five' 4-6-0s were designed by Sir William Stanier and introduced in 1934, no less than 842 examples being built.

Left: Colwyn Bay
A general view of the up platform, looking east towards Chester during the 1960s; Colwyn Bay No. 1 Signal Box can be seen in the distance.

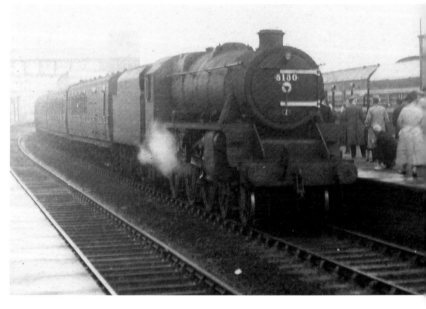

Right: **Colwyn Bay**
Class '25' locomotive No. 25133 passes through Colwyn Bay station with an eastbound parcels working on 5 April 1977. Unusually, the formation included a 3-car class '104' diesel multiple unit that is probably being towed 'dead' after suffering a mechanical failure.

Left: **Colwyn Bay**
An unidentified Stanier 'Black Five' 4-6-0 heads eastwards through Colwyn Bay station with an up freight working during the early 1960s.

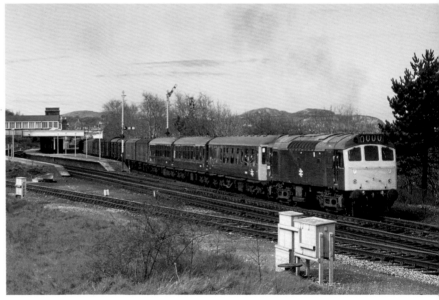

Right: Colwyn Bay

Class '20' locomotives Nos 20151 and 20059 pass through Colwyn Bay with a Crewe to Llandudno railtour on 11 August 1991. The ugly concrete retaining walls were constructed during the 1980s when the A55 Expressway was built within a few feet of the railway, obliterating the site of the low level goods yard and causing massive disruption at many places along the Chester & Holyhead route.

Left: Colwyn Bay

Stanier streamlined Pacific No. 6220 *Coronation* is seen at Colwyn Bay in 1938, possibly on a 'running-in' turn from Crewe Works. This locomotive had been built at Crewe in the previous year and was the first member of its class. Its streamlined boiler casing was designed as a result of experiments carried out in a wind tunnel at the LMS Research Station at Derby.

No. 6220 had reached a maximum speed of 114 mph on its demonstration run in June 1937.

Left: Mochdre & Pabo

From Colwyn Bay, the line heads south-westwards for a distance of 4 miles to Llandudno Junction, passing, en route, the site of a long closed station at Mochdre & Pabo (63¼ miles), which was opened on 1 April 1889 and rebuilt when the line was quadrupled in 1904. Mochdre & Pabo was deleted from the railway network as long ago as 1931, and its site has now been transformed by the construction of the A55 'Expressway', the railway having been realigned in 1984 to provide sufficient room for the new road.

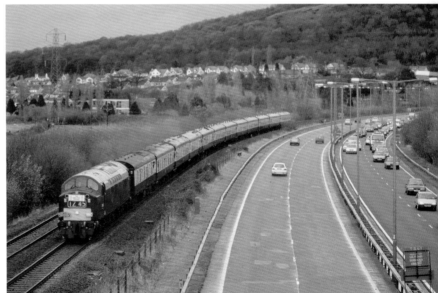

Right: **Mochdre & Pabo**

Class '40' locomotive No. D345 (TOPS No. 40145) runs alongside the busy A55 road at Mochdre with the 7.00 a.m. Pathfinder Tours/Class Forty Preservation Society Crewe to Holyhead 'Christmas Cracker IV' railtour on 30 November 2002. This was the first time that a class '40' had appeared on the national rail network since sister engine No. D200 ran its final railtour in 1988. No. D345 is now preserved on the East Lancashire Railway.

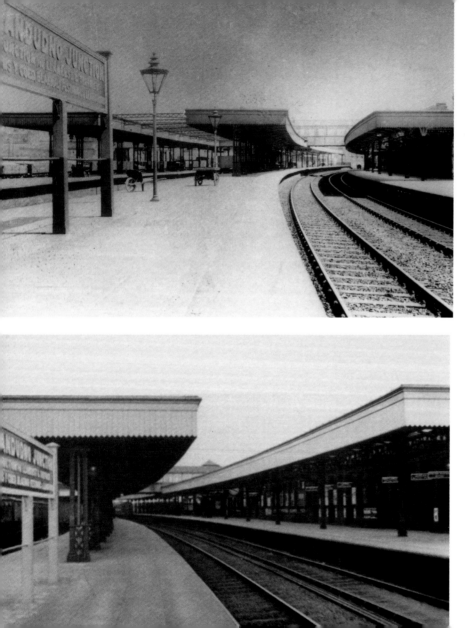

Llandudno Junction

Llandudno Junction (65½ miles) was first opened in 1858, but the opening of the Conwy Valley line increased its importance as a traffic centre, and the station was reconstructed in the 1890s, with a new station opening on 1 October 1897. The rebuilt station, which was to the east of the original, is shown in the accompanying photographs. It featured twin island platforms; the northernmost platform had two bays at its west end and the southern island had two similar bays at its east end. There were thus eight platforms faces in all, four of these being terminal bays for local workings.

There were extensive buildings on both platforms, together with a street-level building on the north side. A fully enclosed footbridge, with prominent luggage lifts, extended laterally across the entire width of the station, and the platforms were covered by generously proportioned canopies. The goods yard was sited to the north of the platforms on the up side, and there was, in addition, a rail-served brick works to the south of the station, which was reached via a private siding connection.

At the time of writing, the station has four operational platform faces; Platform 1 on the north side is used by eastbound services to Chester and beyond, together with Conwy Valley services between Llandudno and Blaenau Ffestiniog. Platform 2, the adjacent bay platform, is used by hourly shuttle services to Llandudno, while Platform 3 is signalled for two-way working and can be used by all services. Finally, Platform 4 is used by services to Bangor, Holyhead and Llandudno, and it is also signalled for trains to Blaenau Ffestiniog.

Llandudno Junction

Above: The east end of the platforms, looking towards Chester during the 1960s. The station was signalled from two standard L&NWR signal boxes, No. 1 Box being sited at the east end of the station near the Conwy Valley branch junction, while No. 2 Box was sited at the west end of the platforms, and controlled access to the engine shed and carriage sidings, as well as the junction with the Llandudno branch. No. 1 Box contained a tumbler frame with 101 levers; these were numbered from 1 to 99, with two further levers being designated lever 'A' and lever 'B'. This box was closed in May 1968, after which the entire layout was controlled from No. 2 Box.

No. 2 Box contained no less than 154 levers and at busy periods it was worked by two signalmen, one of whom operated levers 1 to 77, while the other controlled the remaining half of the frame. Additionally, a third man was employed to fill in the train register and carry out other duties. No. 2 Box was closed in February 1985, when a new panel box was opened on a contiguous site.

Below: The construction of the new station entailed a diversion of the Conwy Valley branch, which was deviated for a distance of about half a mile to form a connection with the down slow line at the eastern end of the station. The superseded portion of the Conwy Valley branch remained in situ for much of its length as a siding and head-shunt, giving access to Llandudno Junction engine shed and the neighbouring carriage sidings. In 1983, the branch junction was moved slightly eastwards to allow room for a new freight terminal to be built in place of the original goods yard. The photograph shows class '37' locomotives Nos 37225 and 37075 entering Llandudno Junction with the 5.55 a.m. Pathfinder Tours Cardiff Central to Amlwch 'Anglesey Odyssey' railtour on 11 September 1993. The re-sited junction is visible to the right.

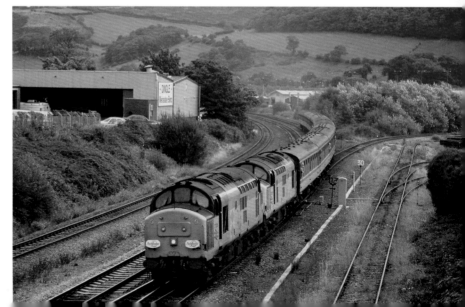

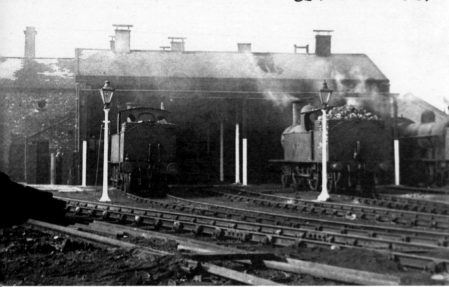

LLANDUDNO JCT

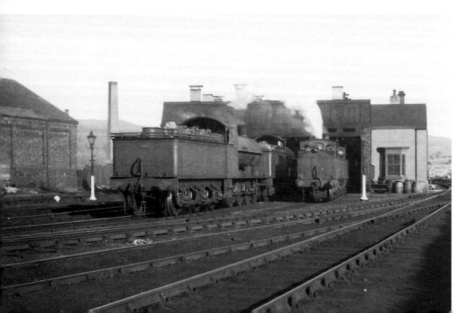

Llandudno Junction – The Engine Sheds

These two photographs show L&NWR 0-8-0, 0-6-2T and 2-4-2T locomotives outside Llandudno Junction engine shed. The shed was sited alongside the original Conwy Valley branch on the down side of the running lines, and it incorporated four roads, together with coaling and watering facilities and a turntable.

On Tuesday 15 November 1898, *The Times* reported that 'on Sunday night a fire had broken out in the extensive range of engine sheds at Llandudno Junction, and before it could be extinguished a portion of the sheds and some property adjacent were destroyed'. Some anxiety was occasioned by the fact that a number of engines were in the burning shed, but fortunately 'one of the engines had steam up, and the officials eventually succeeded, with this available engine, in drawing the remainder into a place of safety without damage'.

In 1959, the locally based engines included six Stanier class '3MT' 2-6-2Ts, three Fowler class '3MT' 2-6-2Ts; three Fowler class '2P' 4-4-0s; one class '4P' Compound 4-4-0; two Fowler class '4F' 0-6-0s; and eight Ivatt class '2MF' 2-6-2Ts. The shed was closed to steam on 3 October 1966, a few months before the end of steam operation in North Wales. In addition to its engine shed, Llandudno Junction was the site of a large carriage shed with six covered roads, this gable-roofed structure being sited a few yards to the north of the engine shed. In recent years, the carriage shed was used for stabling diesel locomotives and multiple units as the former steam shed had been demolished.

Opposite: Llandudno Junction

Former Southern Railway 'King Arthur' class 4-6-0 No. 777 Sir Lamiel enters Llandudno Junction with the 11.55 a.m. BR InterCity Crewe to Holyhead 'North Wales Coast Express on 11 August 1991'. This train ran on several weekends throughout the summer of 1991.

Deganwy

On leaving Llandudno Junction, trains bound for Llandudno proceed westwards along the main line for a short distance, before reaching their own line at the western extremity of the station complex. In steam days, the A55 road had crossed the Llandudno branch on the level immediately to the north of the junction, and this busy level crossing was controlled from Llandudno Junction Crossing Box – a 10-lever box sited on the down side of the running lines. The box had been built in 1949 to replace an earlier L&NWR cabin, which was taken out of use in 1968 when the notorious level crossing was replaced by a new road bridge.

Having entered the branch, trains run north-westwards along the side of the estuary for a little over one mile to Deganwy (66¾ miles from Crewe). This small station has up and down platforms, linked by a lattice girder footbridge. The now demolished main station building, on the up side, incorporated a two-storey stationmaster's house, while the 18-lever signal box, designated Deganwy No. 2 Box, stood sentinel on the down side of the line; it controlled a gated level crossing that gave access to the beach.

When the Ffestiniog slate quarries were in full production, Deganwy had been of great importance, in that it was the site of extensive slate wharves from which slate was loaded from rail to ship. To expedite the flow of this traffic, the North Western introduced a fleet of special transporter wagons, so that narrow gauge slate wagons could be conveyed to Deganwy Pier, where they were off-loaded onto specially laid narrow gauge sidings. In later years, the wharf sidings were used mainly for carriage stabling purposes as the Welsh slate industry had virtually died after the Second World War.

The wharf sidings were controlled from another standard L&NWR signal box, known as Deganwy No. 1 Box, which stood on the up side of the running lines at the south end of the station. Although No. 1 Box was positioned next to a level crossing, the gates were controlled from a separate ground frame sited on the opposite side of the line.

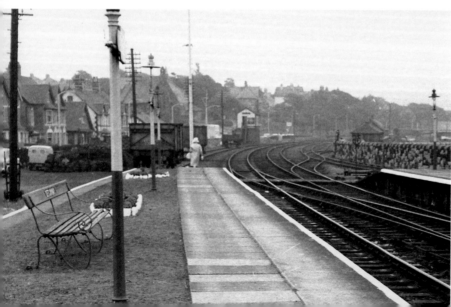

Llandudno

Departing from Deganwy, trains continue northwards and, with Conwy Bay now visible to the west, they soon reach Llandudno (69 miles), the terminus of the 3-mile branch from Llandudno Junction. Llandudno station was opened in 1858, but the original terminus became inadequate in coping with increasing levels of passenger traffic and an enlarged station was opened in 1892. Victorian Llandudno was a somewhat select 'watering place', although in later years, following the introduction of holidays with pay, this attractive seaside town developed into a holiday resort in the accepted sense of the term, and by the mid-twentieth century it was thriving as a holiday destination for large numbers of people.

The new station was well laid out to handle these summer visitors, with five long terminal platforms and an extensive triple-span overall roof, together with a carriage road of exceptional width between the two groups of terminal platforms. The platforms were numbered in sequence from 1 to 5 – Platform 1 being on the east side of the train shed, while Platform 5 was to the west. The upper picture shows the southern end of the train shed during the 1950s, while the lower photograph is an interior view, with Platform 5 on the extreme right.

The station was signalled from two standard L&NWR signal boxes. 'Llandudno No. 1 Box', which had 15 levers, was sited at the station throat, and it controlled the south end of an array of carriage sidings known as 'Cae Mawr' sidings, while the much bigger No. 2 Box, with 86 levers, was situated to the south of the platforms on the down side. Llandudno No. 1 Box was closed on 13 September 1970. Although Llandudno had no engine shed (at least not in modern times), there was provision for visiting locomotives in the form of an engine siding and associated turntable, these facilities being conveniently sited beside Cae Mawr carriage sidings.

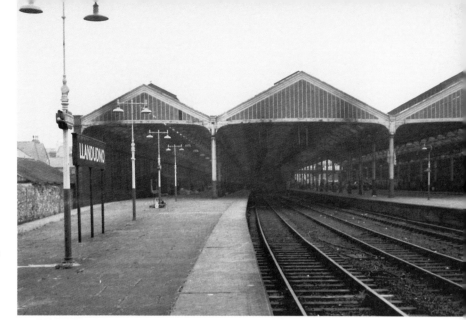

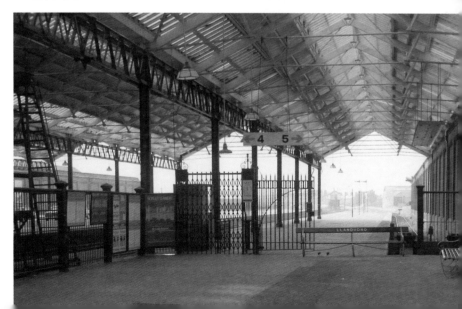

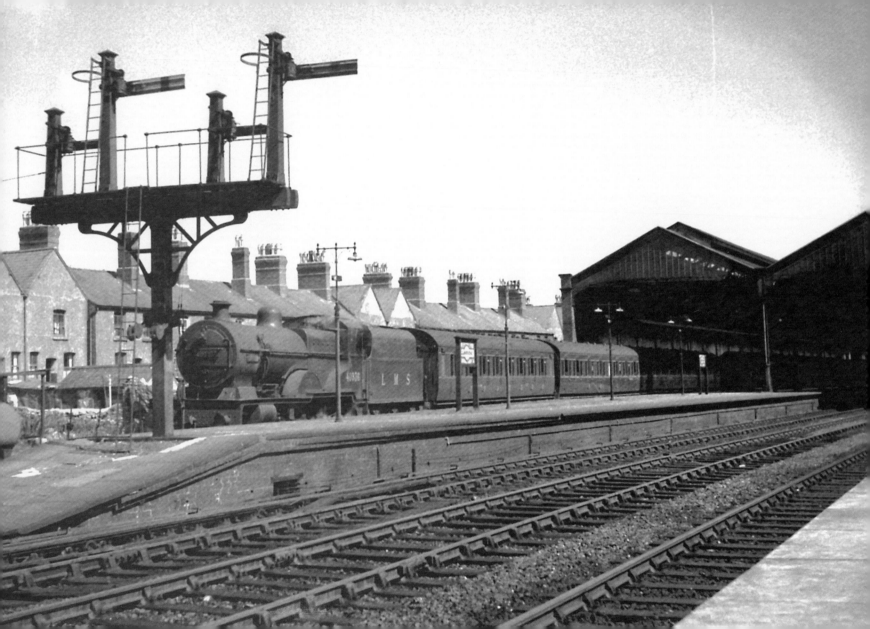

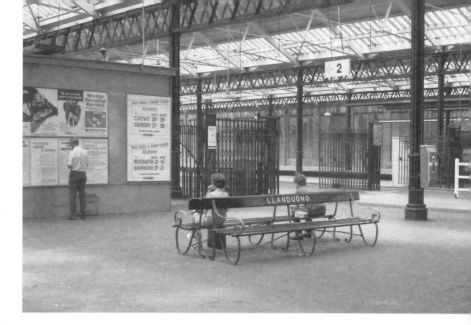

Llandudno

A further view showing the interior of the train shed around 1968. Llandudno goods yard was situated immediately to the east of the passenger station – the goods shed being attached to the side of the train shed. The 1938 *Railway Clearing House Handbook of Stations* reveals that Llandudno was able to deal with a full range of goods traffic, including coal, livestock, horse boxes, vehicles and general merchandise, while the yard crane had a capacity of 5 tons. A private siding served the local gasworks, the gasworks being, in effect, a short branch that diverged on the up side near the carriage sidings, and then curved through 90 degrees in order to enter the premises of the Llandudno Gas Co. The goods yard continued to handle coal traffic until final closure in May 1976.

Llandudno – Tickets

A selection of LMS and BR tickets from the Colwyn Bay and Llandudno areas, including two paper platform tickets and an Edmondson card bicycle ticket.

Opposite: Llandudno

LMS '4P' compound 4-4-0 No. 40936 waits in Platform 5, probably during the mid-1930s. Platforms 3 and 4 can be seen in the foreground.

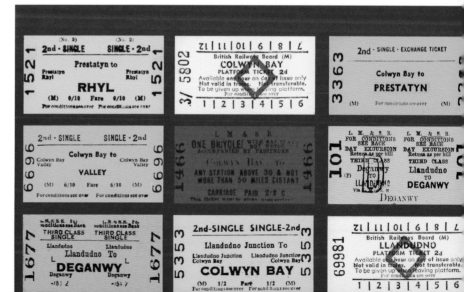

The Great Orme Railway, Llandudno.

Llandudno – The Great Orme Tramway

Above: Quite apart from its historical and scenic attractions, Llandudno is something of a Mecca for transport enthusiasts, insofar as it is the site of the cable-worked Great Orme Tramway – Britain's longest funicular railway. This 3-foot 6-inch gauge line was opened on 31 July 1902, and its original bogie passenger cars, Nos 4, 5, 6 and 7, have remained in use until the present day.

Below: Until 1956, the town could also boast a 3-foot 6-inch gauge electric tramway in the form of the Llandudno & Colwyn Bay Electric Railway, which ran through the town and out along the coast, its open-topped tramcars very similar to the somewhat smaller vehicles in use on the Seaton Tramway.

Opposite: Llandudno

Llandudno station has been severely rationalised in recent years, most of the carriage sidings having been lifted in 1973, while Platforms 4 and 5 were taken out of use in 1978. These reductions left very little siding capacity during the busy summer months, when incoming excursions had to be accommodated in what had become a much smaller terminus. In conjunction with the removal of supposedly 'redundant' trackwork, the southern portion of the train shed was removed, and the remaining roof covering was further cut back in 1990. The photograph shows class '40' locomotive No. 40104 and class '47' locomotive No. 47616 at Llandudno on 30 August 1984 – No. 40104 being at the head of the 4.40 p.m. Llandudno to Birmingham New Street additional, while No. 47616 prepares to depart with the 1.24 p.m. service to Scarborough.

Much of the station frontage was demolished in May 2009, although the three remaining platforms could still accommodate ten-coach trains, and Platforms 4 and 5 were retained as sidings. At the time of writing there are plans for a rebuilding of the station, which will sadly involve the demolition of the Victorian station frontage and the construction of a new 'transport interchange' on the site of Platforms 4 and 5.

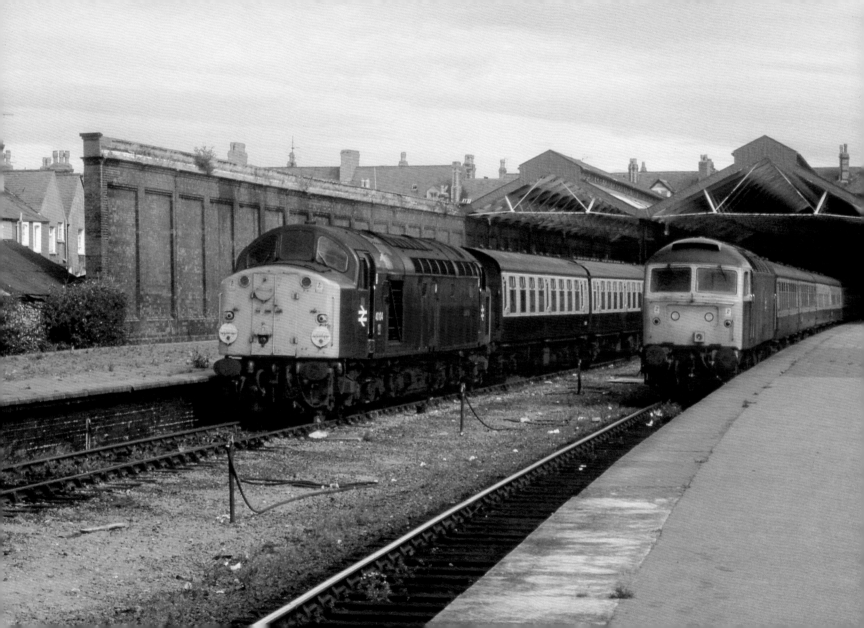

Conwy

Having examined the important branch line to Llandudno, we must now return to Llandudno Junction, in order to continue our journey along the Chester & Holyhead main line. Parting company with the Llandudno line, Holyhead trains run south-westwards along a narrow causeway before crossing Robert Stephenson's tubular bridge, which is situated alongside Thomas Telford's suspension bridge, in the shadow of mighty Conwy Castle – a thirteenth-century fortress erected by Edward I as part of his campaign against Prince Llywelyn.

Conwy station (66½ miles) was situated a short distance beyond the bridge. Opened on 1 May 1848, this two platform station was situated on a curve, with its main station building on the up side. The latter structure, designed by Francis Thompson, was a two-storey Gothic style building incorporating a central block and two gabled cross-wings. A single-storey building, also in the Gothic style, was provided on the down platform, while the two sides of the station were linked by a lattice girder footbridge that abutted an adjacent road overbridge carrying Rosemary Lane across the railway. The goods yard occupied a restricted site to the east of the platforms on the up side, while a further siding on the down side served the local Signal & Telegraph Department.

The upper photograph, dating from around 1958, is looking west towards Holyhead. The main station building can be seen to the right, while the 74-yard Conwy Tunnel is visible in the background. The lower view is looking eastwards along the up platform, the down station building being partially-hidden by the Rosemary Lane bridge.

Opposite: Conwy

A panoramic view showing Conwy Castle and the neighbouring bridge on 30 August 1983. The span of the twin tubes was reduced from 400 feet to 310 feet in 1910, when additional supporting cylinders were inserted beneath the tubes to strengthen the bridge. A four-car dmu formation is heading eastwards on the up line, while class '47' locomotive No. 47482 emerges from the down tube with the 1.20 p.m. Crewe to Holyhead service.

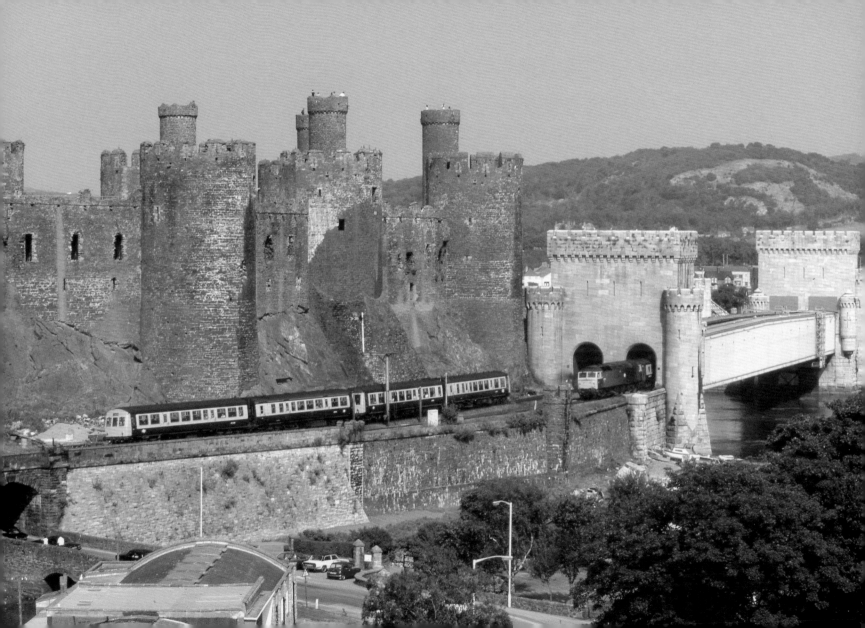

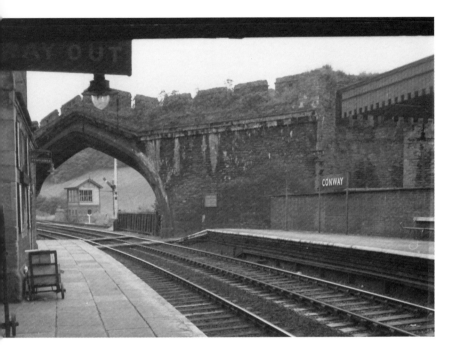

Right: Conwy

The hawthorn is in full bloom at Conwy as class '37' locomotives Nos 37608 and 37612 accelerate away from a rainswept Conwy with the 1.18 p.m. Blaenau Ffestiniog to Crewe 'Railway Magazine special' on 20 May 2000. Sister engines Nos 37029 and 37379 are out of sight at the rear of the train; these would be used to head the excursion back to Crewe after its reversal at Holyhead. As a footnote, it should perhaps be mentioned that the original station was always known as 'Conway', although the correct Welsh spelling was adopted when the station was reopened in 1987.

Opposite: Conwy

This commercial postcard shows Conwy Castle and the Conwy Tubular Bridge from the north, probably during the mid to late 1920s.

Left: Conwy – Closure & Revival

This view, dating from around 1960, is looking east towards Chester, and it shows the decorative Gothic arch that was constructed by the railway company so the C&HR line could pass through the town's medieval wall. As mentioned on page 34, Conwy became a victim of the February 1966 closure programme, but, in the early part of 1987, it was announced that the platforms would be reinstated on a site between Rosemary Lane and the town wall after Gwynedd County Council agreed to finance the reopening at a cost of £200,000. The station was ceremonially reopened on Saturday 27 June 1987, while public services began on the following Monday.

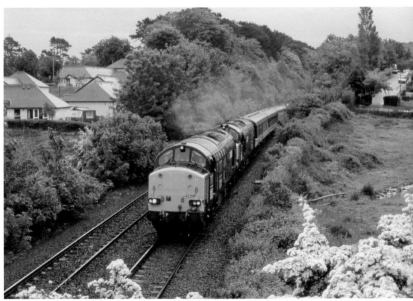

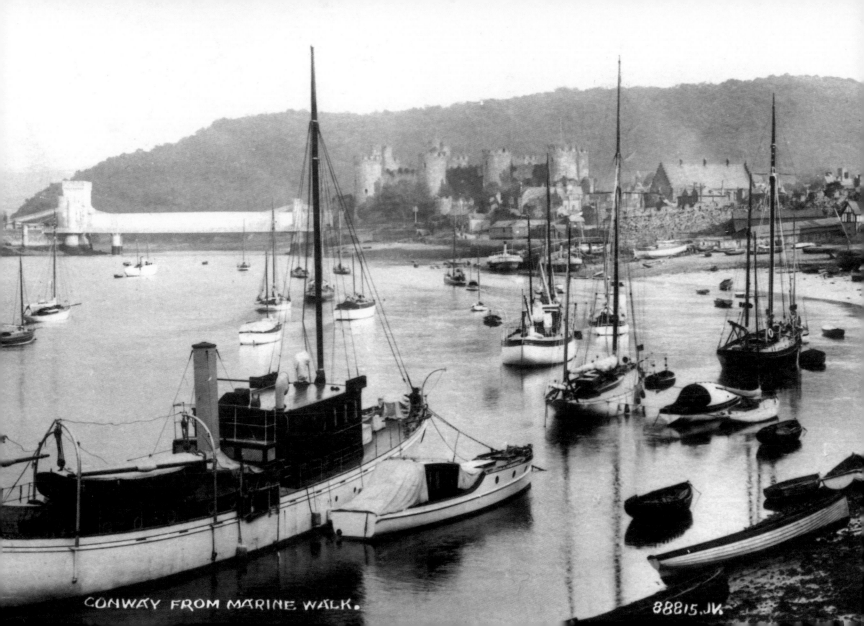

CONWAY FROM MARINE WALK.

88815. JV.

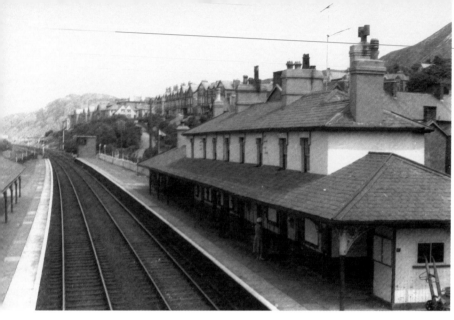

Penmaenmawr

Continuing westwards along the coastline, down trains pass through Penmaenbach Tunnel, beyond which the railway turns south-westwards as it approaches the next stopping place at Penmaenmawr (71 miles). This two-platform station boasted a large, two-storey station building on the down platform, together with a substantial, single-storey building on the up side – the main building being of typical Chester & Holyhead design, as shown in the upper photograph, which is looking east towards Chester around 1960. The lower view, dating from 1953, is looking westwards in the opposite direction. The great stone headland that gave the town its name can be seen in the background.

Although Penmaenmawr had a small goods yard on the down side, the principal form of freight traffic was stone, which was handled in a complex of sidings on the up side. The infrastructure here included a 3-foot gauge tramway, which crossed the main line at right angles and terminated on a jetty to facilitate the export of stone by coastal steamers. In more recent years, granite has been loaded in new sidings on the down side of the running lines.

Opposite: Penmaenmawr

This *c.* 1930s postcard provides a panoramic view of the station in LMS days.

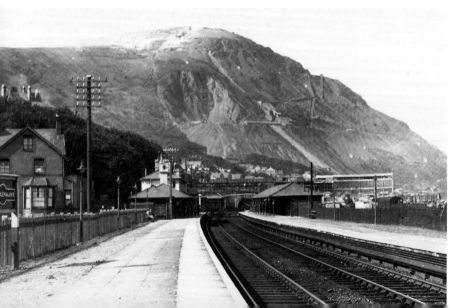

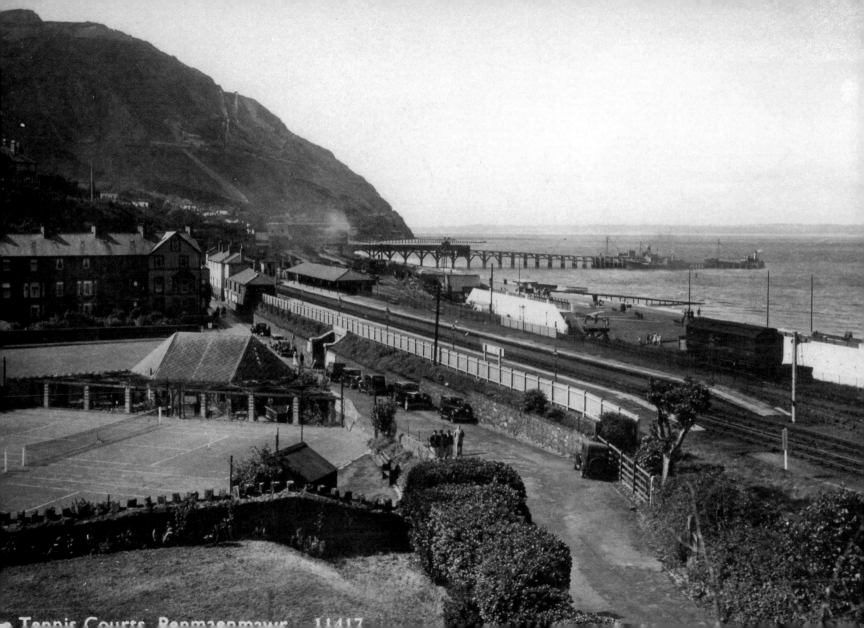

Tennis Courts, Penmaenmawr. 11417

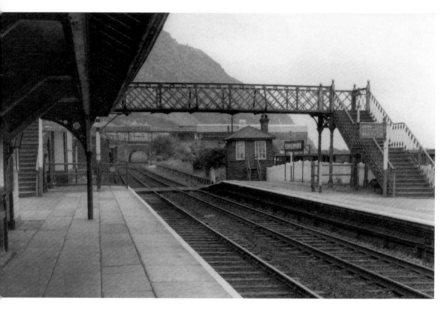

Left: **Penmaenmawr**
A detailed view showing the west end of the platforms, which are linked by a lattice girder footbridge.

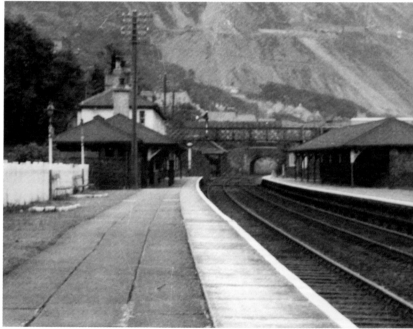

Right: **Penmaenmawr**
This *c.* 1962 photograph is looking westwards along the down platform. The Italianate station building, now Grade II listed, is no longer in railway use, although its lengthy veranda continues to offer protection to travellers during periods of inclement weather. The building on the up side has now been partially demolished.

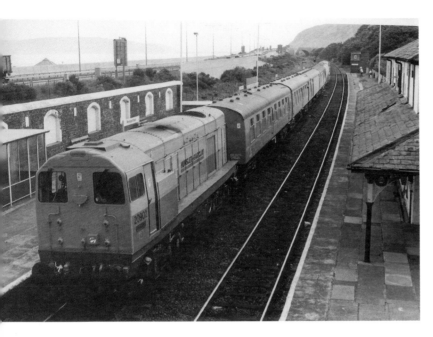

Left: **Penmaenmawr**

A weedkilling train passes through Penmaenmawr station on 4 June 1997 with class '20' locomotive No. 20902 at the rear end; the train was returning to Llandudno Junction from Holyhead. The remains of the up side station building can be seen to the left.

Right: **Penmaenmawr – The 1950 Train Crash**

Penmaenmawr was the setting for an accident that took place shortly after 3.00 a.m. on the morning of 27 August 1950. The up Night Irish Mail, headed by rebuilt 'Royal Scot' class 4-6-0 No. 46119 *Lancashire Fusilier*, collided with 'Crab' 2-6-0 No. 42885, which had moved onto the up main line during the course of shunting operations. There was severe damage to five of the sixteen coaches of the Irish Mail, including the destruction of a sleeping car near the front of the train. Six people were killed and a further thirty-four were injured – although eleven passengers and the driver of the Irish Mail were discharged from hospital on the same day. The official report, published 31 January 1951, attributed blame mainly to the Penmaenmawr signalman. He had accepted the Express and lowered the signals for it before the 2-6-0 had moved clear of the running line. The photograph shows the express locomotive being removed from the scene of the accident.

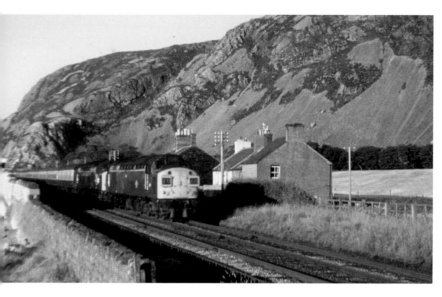

Right: Penmaenmawr – Class '40' Locomotives

The triumphant return of a class '40' to the main line occurred on 30 November 2002 when locomotive No. D345 (later re-numbered 40145) worked the 7.00 a.m. Pathfinder Tours/Class Forty Preservation Society Crewe to Holyhead 'Christmas Cracker IV' railtour. The weather was very poor, but had brightened up a little when the train reached the North Wales coast. It is seen here running between the A55 road and Conwy Bay at Penmaenmawr. With three headboards, even a non-railway enthusiast would recognise this working as a railtour!

Opposite: Penmaenmawr

Class '37' locomotive No. 37275 *Oor Wullie* leaves Penmaenmawr with the 11.03 a.m. ballast train to Warrington on 9 August 1995. The highly inappropriate Scottish name can be explained by the fact that the locomotive had been transferred from Motherwell to Bescot just a few months previously. Note the extensive quarry workings on the hillside in the background.

Left: Penmaenmawr – Class '40' Locomotives

Steam power remained much in evidence on the Chester & Holyhead line until the 1960s and, as late as the summer of 1966, youthful 'spotters' could be sure of seeing a procession of BR and former LMS classes on the Holyhead main line. A few steam locomotives continued to work over the Chester & Holyhead route in the early months of 1967 but, thereafter, diesels reigned supreme. Many of the best trains were worked by English Electric class '40' locomotives, as shown in this 35-mm colour slide view of the westbound Emerald Isle Express at Penmaenmawr around 1974. These 130-ton locomotives were themselves withdrawn for scrapping during the late 1970s and early 1980s, the last survivors being retired in 1985.

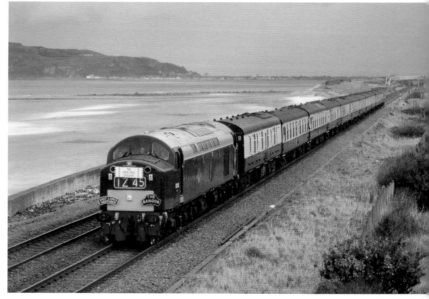

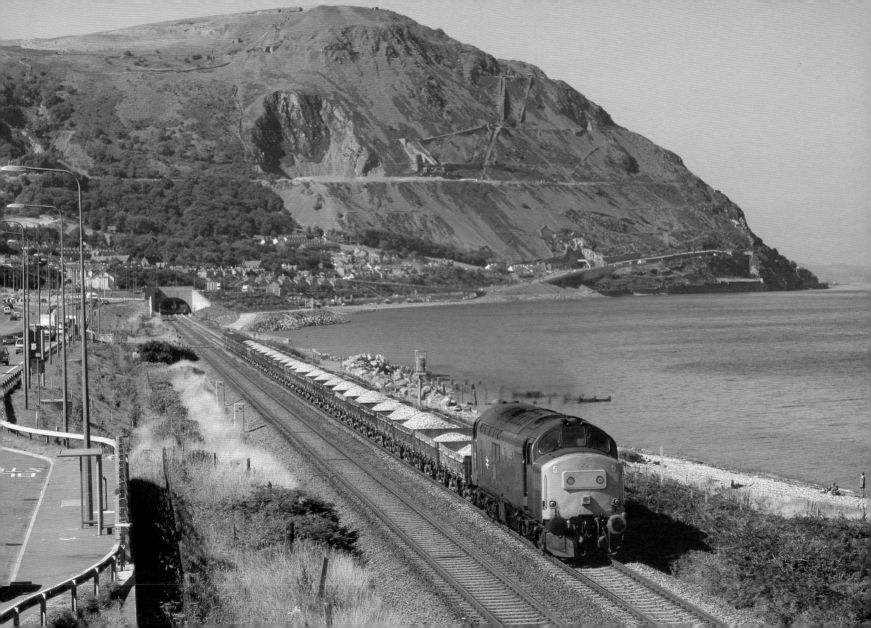

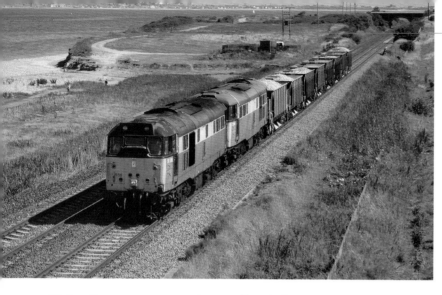

Left: **Penmaenmawr**
Class '31' locomotives Nos 31556 and 31144 pass through Penmaenmawr with the 6.06 a.m. Edge Hill to Penmaenmawr working on 9 August 1995. This was supposedly an empty ballast working, but most of the wagons were in fact going back to the quarry still filled with stone.

Right: **Penmaenmawr – Pen-y-Clip Viaducts**

In 1899, Sir Benjamin Baker was called in to advise on the preservation of the main coastal road in the vicinity of Penmaenmawr and, as a result, massive retaining walls were constructed to prevent erosion. Further work was carried out during the 1930s, when the road was rebuilt and deviated for a considerable distance. The new works included two road tunnels and an arched viaduct, with seven 80-foot spans and a height of around 90 feet – the new road bridge around 70 feet higher than the adjacent railway viaduct. This ambitious new road scheme was opened on 5 October 1935 by the minister of transport, Leslie Hore-Belisha (1893–1957), who cut a red, white and blue ribbon and declared the road 'open for the free use of the King's subjects for ever'. The photograph reproduced here shows one of the road tunnels, while the road and railway viaducts are visible to the right. Penmaenmawr railway tunnel, some 267 yards in length, passes beneath the road tunnels.

Opposite: **Penmaenmawr – Pen-y-Clip Viaducts**

Class '37' locomotive No. 37421 *The Kingsman* crosses the Pen-y-Clip railway viaduct with the 10.23 a.m. Bangor to Crewe service on 15 June 1996. Due to the close proximity of the road and cliffs, this location only gets the sun around midsummer, and even then the area on left is in usually in deep shade.

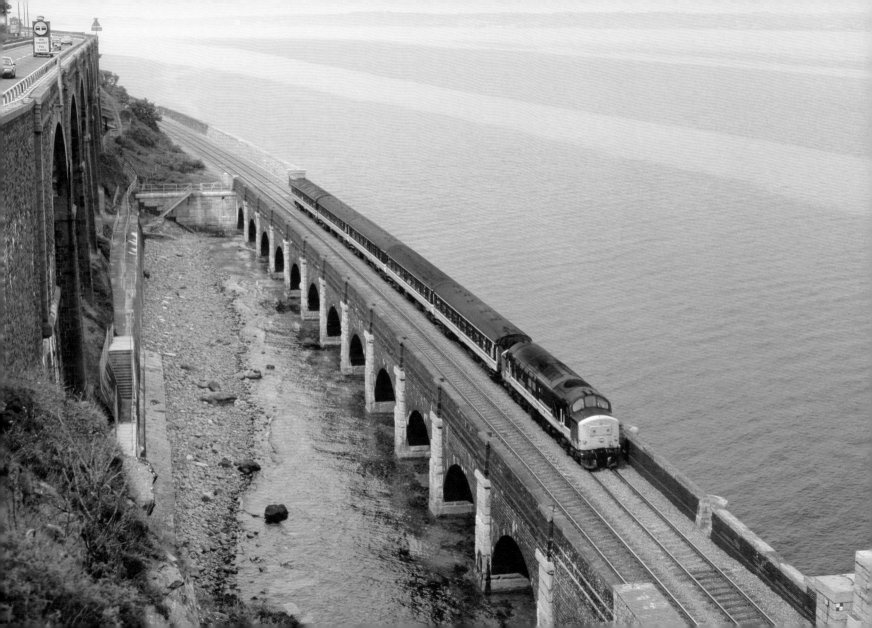

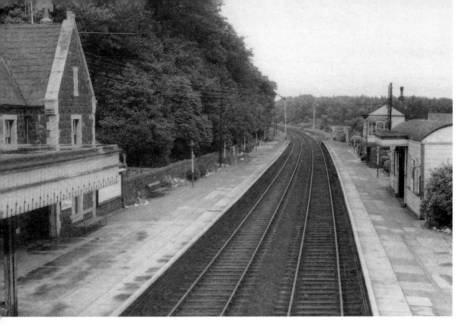

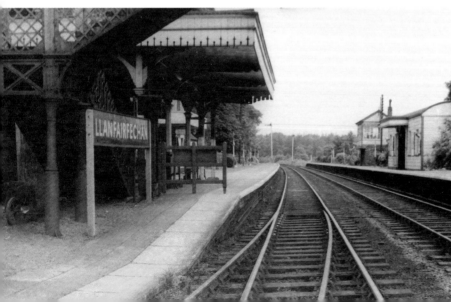

Llanfairfechan

Llanfairfechan, the next stopping place (73¾ miles), was opened on
1 May 1860. The accompanying photographs, both of which were
taken in the early 1960s, are looking west towards Holyhead. The main
station building, on the down side, was a substantial Tudor-Gothic style
structure, while the up platform was equipped with a simple, arc-roofed
waiting shelter. The up and down platforms were linked by a lattice
girder footbridge, and the station was signalled from a gable-roofed
signal cabin with an 18-lever frame, the latter structure being sited on the
up platform.

Llanfairfechan's goods-handling facilities were concentrated in a
fairly compact goods yard that was situated to the east of the passenger
station on the down side. According to the 1938 *Railway Clearing House
Handbook of Stations*, Llanfairfechan was able to handle coal, furniture,
livestock, horse boxes and general merchandise traffic, while the yard crane
was of 1-ton capacity. The goods yard remained in use until June 1964.

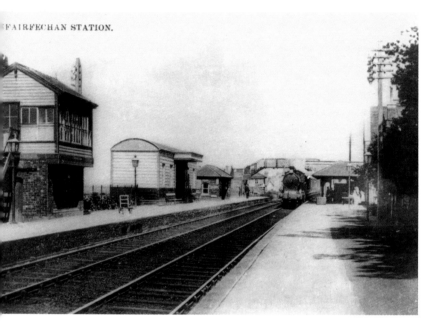

FAIRFECHAN STATION.

Left: Llanfairfechan

A view of the up platform, looking east towards Chester, probably around 1912. The standard North Western signal box was opened in 1889 to replace an earlier, hip-roofed cabin that remained in situ for many years beside the up line. The old cabin can be seen beyond the footbridge.

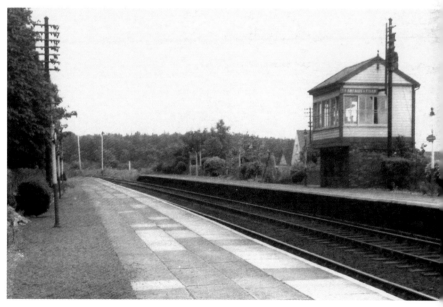

Right: Llanfairfechan

A further view of the signal box, which remained in use until August 1967. It is not entirely clear why the upper storey should have been somewhat wider than the operating room – the likeliest explanation being that the upper floor was widened at some stage, perhaps to improve the signalman's view past the adjacent up side station building. Llanfairfechan station is still open for passenger traffic, although its buildings have now been replaced by simple waiting shelters.

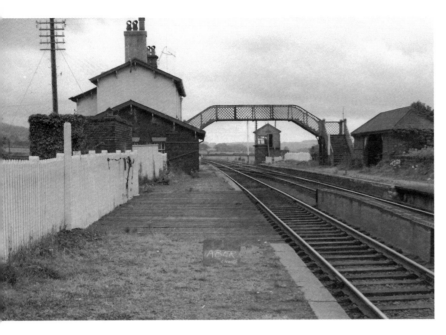

Left: Aber

Still hugging the coast, the railway continues along more or less dead-level alignments towards Aber (75¾ miles), this now-closed station being preceded by a modest rising gradient of 1 in 175. Opened by the C&HR on 1 May 1848, Aber was closed with effect from 12 September 1960. It was a simple, two-platform stopping place, with its main station building on the down side and a waiting shelter on the opposite platform. The up and down platforms were linked by a lattice girder footbridge, while the two-storey station building was a typical Chester & Holyhead structure that incorporated living accommodation for the stationmaster and his family, as well as the usual booking office and waiting room facilities. A standard L&NWR signal cabin, with a 15-lever frame, was sited to the west of the platforms on the up side and remained in use until 1989.

Right: Aber

This 1960s view is looking east towards Chester, the C&HR station building being visible to the right. Aber's track layout incorporated a two-siding goods yard at the rear of the down platform, together with a refuge siding, which was sited immediately to the east of the down platform. The goods yard sidings were entered by means of a trailing connection from the down main line, but there was no direct link to the up line, which meant that the yard could not be shunted by eastbound goods trains. The 1938 LMS Working Timetable reveals that Aber was, at that time, served by just one pick-up goods working that left Mold Junction in the morning and called at the station to pick up or set down traffic as required. Any up traffic was worked forward to Menai Bridge Yard and then sent back by the next convenient up train.

Bangor

From Aber, trains continue south-westwards for a little over 5 miles to Bangor (81 miles). This station, opened on 1 May 1848, occupies a restricted site between two tunnels – Bangor Tunnel is immediately to the east of the platforms while Belmont Tunnel occupies a corresponding position to the west. In L&NWR days the track layout had incorporated a side platform on the up side and an island platform on the down side, the up platform having a bay at its western end. Although there was a spacious quadruple track layout, these facilities were insufficient in relation to the traffic that the station was called upon to handle, and an enlargement scheme was therefore put into effect during the 1920s in order to provide much improved accommodation for both passenger and freight traffic. In its new guise, the station boasted two double-sided platforms, the original up platform having been converted into an 'island'. The old up-side bay was removed but, at the same time, a new bay was inserted at the eastern end of the down platform for the benefit of local branch services.

The 1924 alterations had the incidental effect of isolating the Chester & Holyhead station building on the new up island platform, but to obviate this difficulty a modern, brick-built station building was erected in what had hitherto been the station approach. The new building, which included a booking office, parcels office and left luggage facilities, was linked to the platforms by a covered footbridge incorporating electric luggage lifts, while the down platform boasted a range of single-storey buildings and an extensive glass and iron canopy. Similar canopies could be seen on the up side but, otherwise, the most important building on the up platform was the original Chester & Holyhead station building – a two-storey Italianate structure with a low-pitched hipped roof and a profusion of prominent chimney stacks.

The upper picture shows the up platform during the 1960s with the new station building erected by the LMS days visible to the left.

The lower view shows the down platform, again during the 1960s; both photographs are looking east towards Chester.

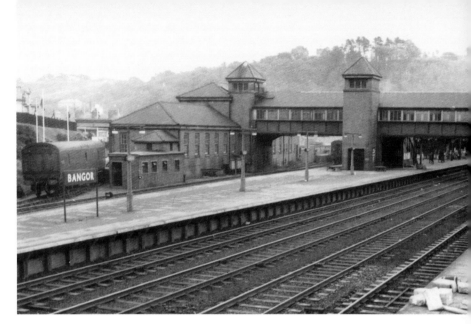

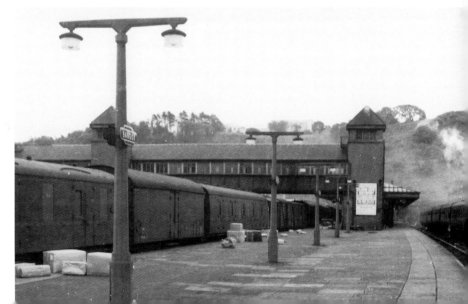

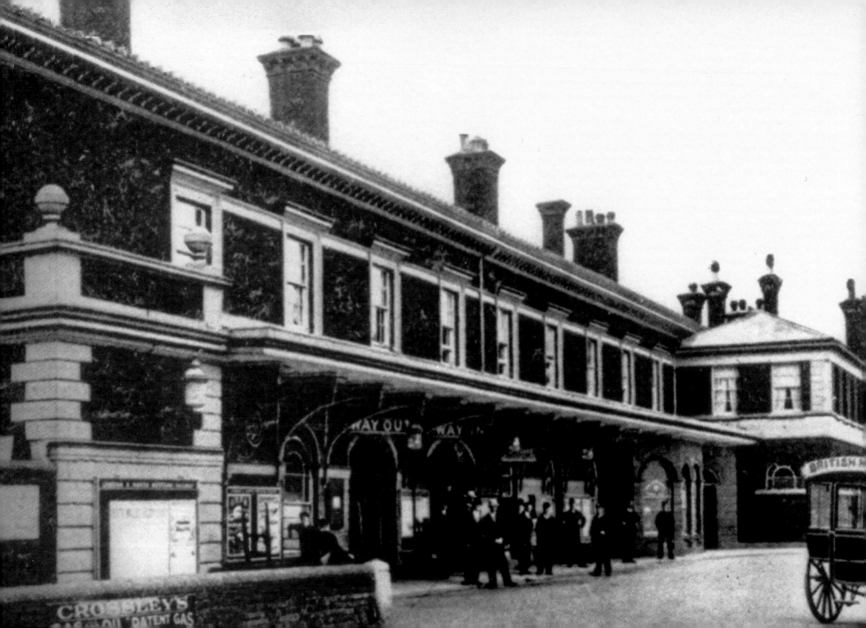

Bangor

Above: The station proper was signalled from two standard L&NWR signal cabins – Bangor No. 1 Box, with 63 levers, sited to the east of the platforms on the down side, and Bangor No. 2 Box, with 90 levers, located at the Anglesey end of the station on the up side of the running lines. The photograph shows No. 2 Box, with Belmont Tunnel visible to the left.

There was ample provision for goods traffic, with an array of sidings available on the down side. The usual range of accommodation was provided, including a large goods shed, together with coal sidings, end-loading docks, cattle loading pens and a 5-ton yard crane. In 1952, Bangor dealt with 81,298 tons of freight, including 21,060 tons of outgoing mineral traffic. The station functioned as a railhead for a large rural area, and towns and villages within a radius of about 10 miles were served by a fleet of locally based collection and delivery vehicles.

Slate traffic was an important source of revenue in North Wales, but in the case of Bangor much of this traffic was handled on the nearby freight-only branch to Port Penrhyn. This branch diverged northwards from the Chester & Holyhead main line at Penrhyn Sidings to the east of Bangor Tunnel, then descended abruptly before terminating on the quay at Port Penrhyn, where connection was made with the narrow gauge Penrhyn Quarry Railway.

Below: A general view of the down platform, looking west towards Holyhead; the buildings on this platform have now been partially demolished.

Opposite: Bangor

An Edwardian postcard view showing the main station building during the early 1900s.

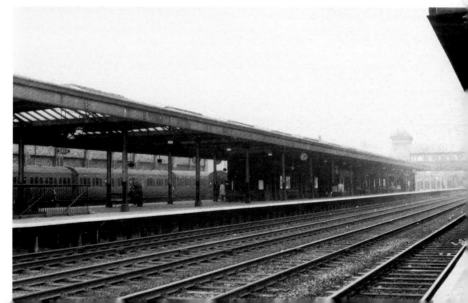

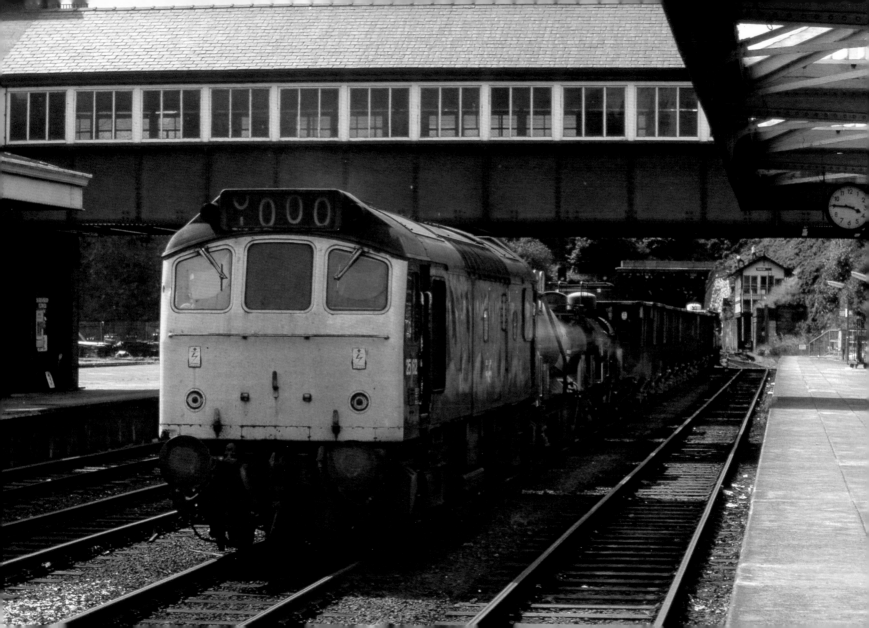

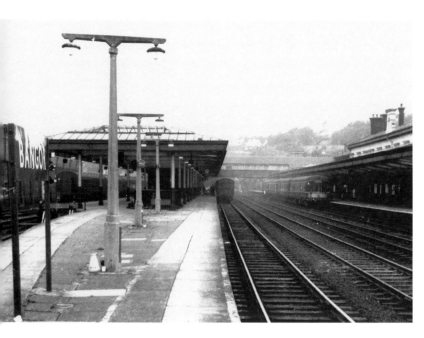

Right: Bangor

A selection of railway tickets from Bangor, Holyhead and intermediate stations on the island of Anglesey. The two platform tickets are paper issues, whereas the BR and LMS travel tickets are Edmondson cards. Bangor station was designated 'Bangor LM' to prevent confusion with Bangor-on-Dee near Wrexham, and 'the other' Bangor in County Down.

Opposite: Bangor Class '25' locomotive No. 25162 passes through Bangor with a short freight train, including chemical tanks from Amlwch, on 25 July 1977.

Left: Bangor

A general view of Bangor station, looking west towards Holyhead in 1953. Bangor's busy motive power depot, which was sited alongside the passenger station, can be seen to the left of the picture. The shed building was a northlight pattern-type structure with six parallel shed roads. The coaling stage was situated beside the shed, and the engine turntable was sited immediately to the south, the latter having a diameter of 60 feet. The normal allocation, during the mid to late 1950s, was around twenty locomotives. In 1959, for example, the resident locomotives included three Stanier class '5MT' 4-6-0s; one BR Standard class '2MT' 2-6-0; four Stanier class '3MT' 2-6-2Ts; five Ivatt class '2MT' 2-6-2Ts; five BR Standard class '4MT' 2-6-4Ts; two Fowler class '4F' 0-6-0s; and two Fowler class '3F' 0-6-0Ts.

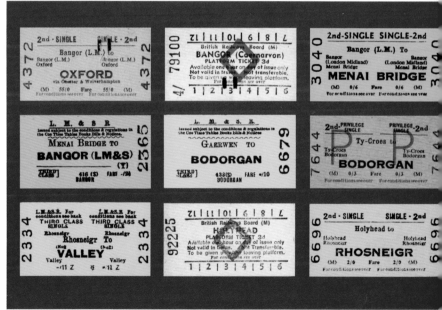

Menai Bridge Station

On leaving Bangor, down trains immediately pass through the 614-yard Belmont Tunnel, beyond which the railway emerges onto an elevated ledge, with the Menai Straits and the Holyhead Road visible to the right. After around a mile, the road swings northwards in order to cross Telford's Menai Bridge, but the railway continues south-westwards for a further three quarters of a mile before turning north-westwards on the approaches to the Britannia Bridge. There was one intermediate station on this part of the C&HR route, a station known as Menai Bridge (82¼ miles), which opened on 1 October 1858 to replace an earlier stopping place called 'Britannia Bridge'. This station was the junction for the Caernarfon branch, which was opened as far as Port Dinorwic in March 1852 and completed throughout to Caernarvon in the following July.

Situated 61 miles from Chester and barely 1½ miles from Bangor, Menai Bridge had two platforms for up and down main line traffic and two platforms for Caernarfon branch services. The platforms were linked by an underline subway, while the station building, on the main up platform, was a Tudor-Gothic style structure with a recessed centre block flanked by two gabled cross-wings. This now demolished building was a split level design – the platforms were at first-floor level. The Beeching Plan sounded the death knell for the section of line between Caernarfon and Afon Wen, which was closed with effect from Monday 7 December 1964. The northern end of the route remained in operation between Menai Bridge and Caernarfon, with a diesel-multiple-unit service of nine trains each way to and from Bangor.

Sadly, Menai Bridge station was closed with effect from 14 February 1966, although the Caernarfon branch came into its own on 1 July 1969, when eleven special trains worked through to Caernarfon in connection with the Investiture of The Prince of Wales. Four of these workings, including the Royal Train, had started from Euston, while four others had come from Cardiff. However, the investiture was destined to be the swansong of the Caernarfon route, which was closed with effect from Monday, 5 January 1970, the last trains being run on Saturday 3 January.

Opposite – **Menai Bridge Station**
A detailed view of the picturesque, Gothic-style station building at Menai Bridge.

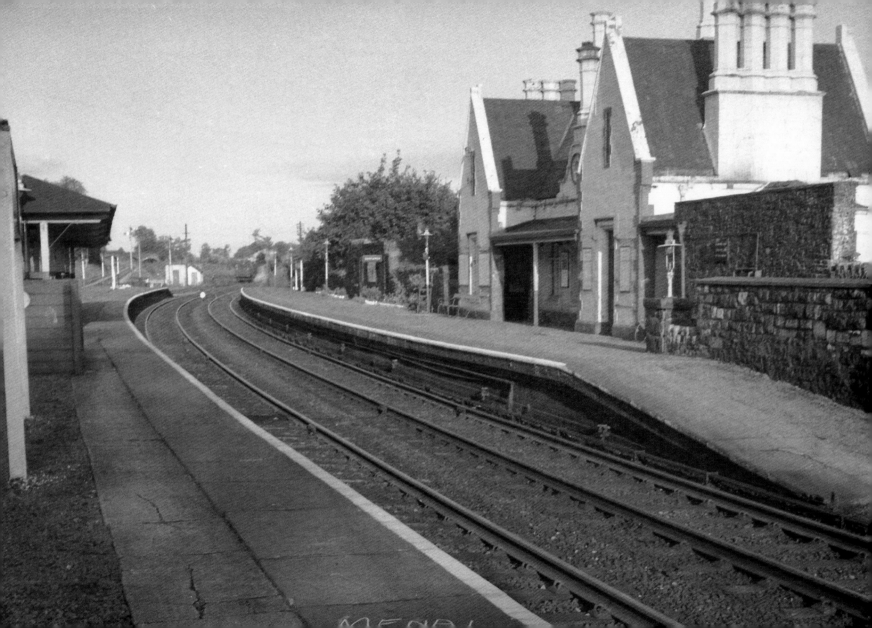

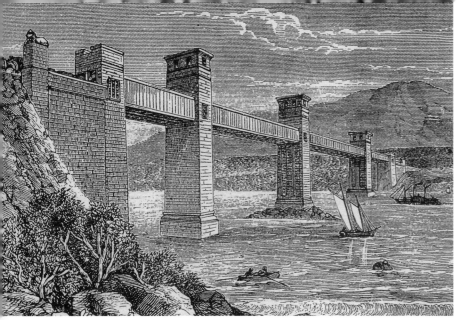

The Britannia Tubular Bridge

Above: Stephenson's original tubular bridge incorporated four twin-tube spans, the main water spans being carried over 100 feet above mean water level on three stone towers or piers. The Britannia Tower, at the centre of the bridge, rises 230 feet from its solid rock foundations, while the two flanking towers have a height of 203 feet. It is interesting to note that they feature square apertures near their very tops, a reminder that Stephenson had originally considered the introduction of suspension chains as a means of further strengthening the bridge. The up and down tubes were covered by a slightly curved, wooden roof, with an overall width of around 30 feet and a protective covering heavily impregnated with tar. The centre tower contained a storeroom and workshop, which was filled with supplies of timber, paint, tar and other materials necessary for maintenance purposes. Access to the stores was by means of a metal door leading from the tubes.

Below: The architectural embellishments on the towers and abutments were probably the work of the architect Francis Thompson, while Robert Stephenson would have concentrated on purely engineering matters such as the design and construction of the tubes. In this context, it should be mentioned that the abutments are graced by four massive stone lions, each of which weigh about 76 tons. It is said that these 25-foot long beasts were originally to have been placed in Trafalgar Square at the base of Nelson's Column, but it was decided that they were not sufficiently fierce, and they were therefore redeployed on the Britannia Bridge. The four lions were carved by the monumental sculptor John Thomas (1813–62), an associate of Francis Thompson.

Opposite: **The Britannia Tubular Bridge**
A detailed look at one of the portals.

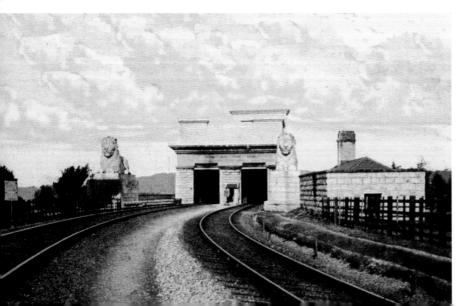

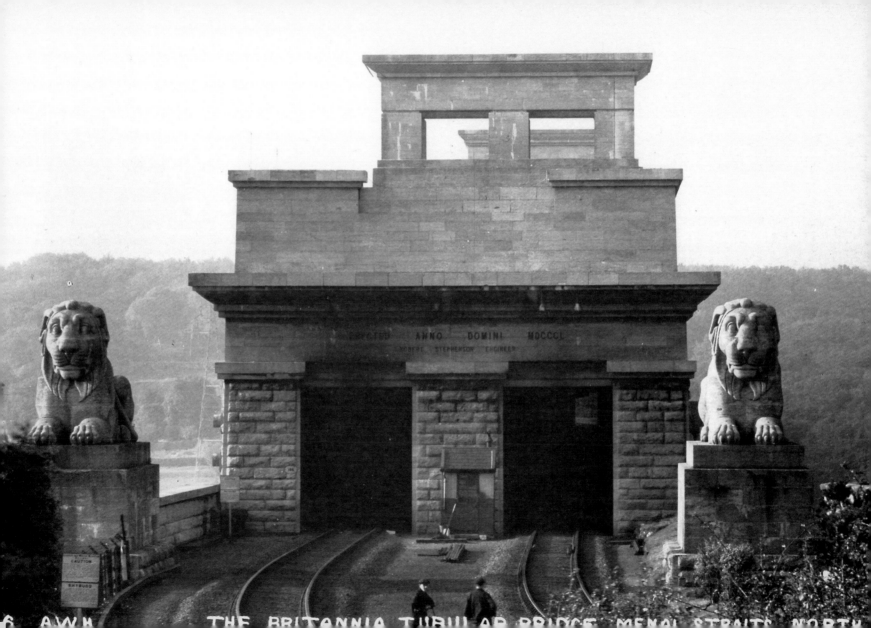

ERECTED ANNO DOMINI MDCCCL
ROBERT STEPHENSON ENGINEER

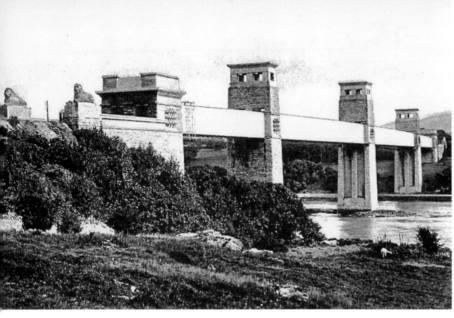

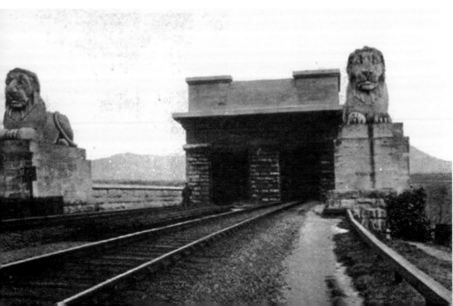

The Britannia Tubular Bridge – The 1970 Fire

One of the most significant events to have occurred on the Chester & Holyhead line in recent years concerned a spectacular fire on the Britannia Bridge. The fire, which was started by local delinquents, was discovered at 9.40 p.m. on Saturday, 23 May 1970 and, despite the efforts of firemen working in extremely difficult conditions, the heavily tarred roof covering was soon well alight along the entire bridge. Like other great fires, the resulting conflagration was 'a grand but awful spectacle', the heat so intense that the metalwork became white hot. It was obvious that the main spans had sagged but, more seriously, when the tubes cooled they split from top to bottom along the original joints within each tower. Emergency repairs were immediately carried out to stabilise the structure and the Royal Engineers were called in to erect temporary supporting trestles which were fabricated from standard Bailey Bridge components.

Some commentators wondered if the railway would ever be restored, but Prime Minster Harold Wilson was so concerned at the dislocation of traffic that two government ministers were flown to Anglesey by the RAF to access the damage. Although it was conceivable that Stephenson's iron tubes could have been repaired, it was decided that the bridge would be reconstructed with arched lattice spans, and the opportunity was taken to add a three-lane road deck above the railway – the additional cost being met by the Welsh Office. The new steel spans were erected beneath the original tubes and, suitably supported, the up tube was brought back into temporary use in January 1972. The down tube was then demolished, and when this melancholy task was completed a single line was laid over a new, permanent rail deck. All traffic was then transferred to the former down line, and the up tube was dismantled. The Britannia Bridge was thereby brought back into use as a single-track bridge – although railway enthusiasts and historians lamented the loss of the historic tubular spans. The accompanying pictures show the famous bridge in happier times.

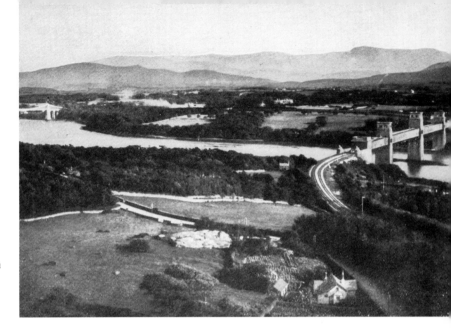

The Menai Straights

This panoramic view of the Menai Straights, dating from around 1900, is looking eastwards from an elevated vantage point. The Britannia Tubular Bridge can be seen to the right, while Telford's suspension bridge is visible on the extreme left of the picture.

The Britannia Tubular Bridge

This artist's impression of the rebuilt Britannia Bridge appeared on the front of a supplement to the May 1971 passenger timetable, which included alterations to the Irish ferry services and the diversion of main line passenger services from Holyhead to Heysham, in addition to the arrangements that were being made for the continuation of local passenger services between Llanfair and Holyhead. The arched lattice spans are clearly depicted, together with the apertures that had to be cut through the towers in order to permit the passage of road traffic on the new upper deck.

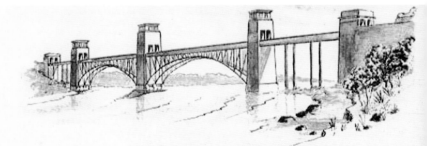

RECONSTRUCTION OF BRITANNIA BRIDGE (MENAI)

Continuation arrangements for the diversion of Irish services from Holyhead to Heysham

...trikes the Britannia bridge

This picture w
taken at t
height of the bla
that crippled t
only rail link
tween the island
Anglesey and t
mainland
Wales.

The fire,
Saturday nigh
was so inten
that the cent
span is now sa
ging and girde
have bent.

The bridge
called the "B
tannia" — w
built in 1850
Robert Stephe
son.

His work was
good that en
neers were call
in only a f
months ago
find how t
bridge had las
under continu
use for 120 yea

Their repo
said: "We fou
it as good
new." It was
until the fire.

Bridge fire: 2 questioned

TWO youths have been questioned by police in connection with a fire that severely damaged the Menai railway bridge.

Forensic science experts examined the bridge yesterday.

The bridge, which spans the Menai Strait between Anglesey and the Welsh mainland, was swept by fire on Saturday night.

Mr. George Thomas, Secretary for Wales, visited the still-smouldering bridge yesterday.

He said later: "The fire is the most serious blow to Anglesey for generations. The conse-quences could have a far bigger effect than is realised at the moment."

A senior British Rail official said: "I cannot say whether the fire was started deliberately or not."

Fire at the Menai Bridge
—Page Five.

The Britannia Bridge & Llanfair PG

Meanwhile, sixteen locomotives had been marooned on Anglesey as a result of the fire and, on 1 June 1970, seven class '40' locomotives, three class '47's and a class '24' were evacuated by sea aboard the motor vessel *Kingsnorth Fisher*, leaving three class '08' shunters and two class '24's on the island to work an emergency rail service in conjunction with a handful of two-car diesel-multiple-units. To facilitate this mode of operation, the wayside station at Llanfair (63¼ miles), on the Anglesey side of Menai Straits, which had been closed on Saturday 12 February 1966, was reopened on 29 May 1970 as the southern terminus of an isolated 21-mile line from Holyhead. A tenuous link to the rest of the railway system was maintained by means of a connecting bus service to and from Bangor, and locomotives ran-round their trains via the crossovers at Llanfair and Gaerwen.

The one bright spot in the story of the Britannia Bridge disaster concerned the subsequent fate of Llanfair station, which was closed for a second time with effect from 31 January 1972, following the reconstruction of the bridge. However, the station re-opened once again on Monday 7 May 1973, with a modest service of five trains each way between Bangor and Holyhead. The upper photograph, which dates from the 1960s, is looking east towards Chester with the two-storey station building to the left of the picture, while the lower view is looking westwards in the opposite direction.

Opposite: The Britannia Tubular Bridge – The 1970 Fire
A montage of newspaper cuttings from the *Daily Mirror* dated Monday 25 May 1970.

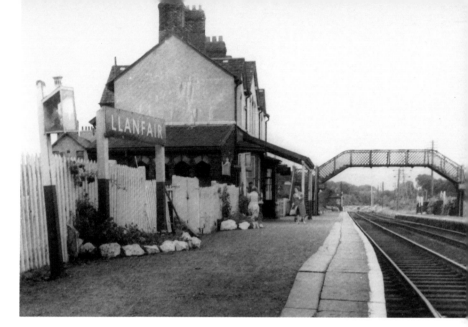

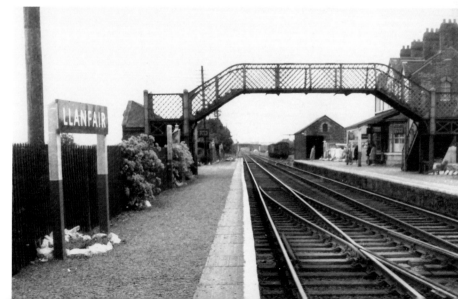

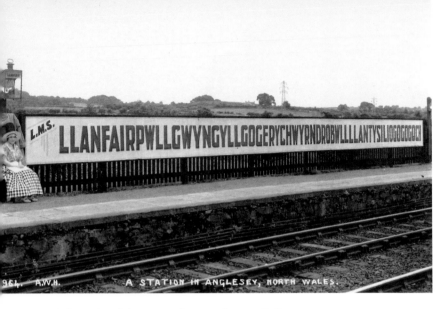

A STATION IN ANGLESEY, NORTH WALES.

Left: Llanfair PG – The Station with the 'Long Name'

Llanfair (84½ miles) serves the village of Llanfairpwllgwyngll which, in the nineteenth century, became known as 'Llanfairpwllgwyngyllgogerychwyrndrobwllllantysiliogogogoch'. The much-expanded name probably originated as hoax, but it nevertheless helped the village to become something of a tourist attraction. When opened on 1 August 1848, the station was known simply as 'Llanfair', although 'Llanfair PG' was sometimes used as an abbreviated version of the famous 'long name'. The full fifty-eight-letter name is still displayed on the station name-board, although when the station was reopened in 1973 it was officially known as 'Llanfairpwll'. The meaning of the 'long name' has been much debated, but it is generally agreed that an acceptable English translation would be 'The Church of St Mary in a Hollow of White Hazel near the Rapid Whirlpool (and the) Church of Tysilio near the Red Cave'.

Right: Llanfair PG – The Station Building

Llanfair's first station building was of wooden construction, but this original structure was burned down on the night of Saturday 6 November 1865. The fire was discovered at a little after 10.00 p.m., and the flames spread with amazing rapidity; several goods wagons laden with flour were totally destroyed, in addition to the station buildings. The *North Wales Chronicle* reported that burning ashes and sparks were blown onto the up line, and 'great excitement' was caused when the Irish Mail train 'dashed through at its usual speed', and one of the carriages 'appeared to be, for a moment, a mass of flame, but no harm occurred'. The L&NWR erected a new brick building with a gable roof and Gothic-style window apertures – the platform façade being distinguished by three prominent gables, while the rear of the building featured a projecting portion with a centrally placed gable, as shown in the photograph.

Opposite: Llanfair PG

Class '37' locomotive No. 37414 *Cathays C&W Works 1846–1993* passes through the reopened Llanfairpwll station with the 4.00 p.m. Holyhead to Crewe service on 11 September 1993. The name-board, which can be seen to the right, needs five posts to support it.

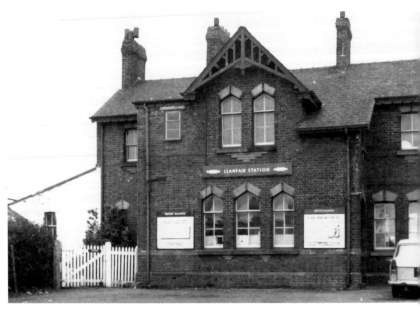

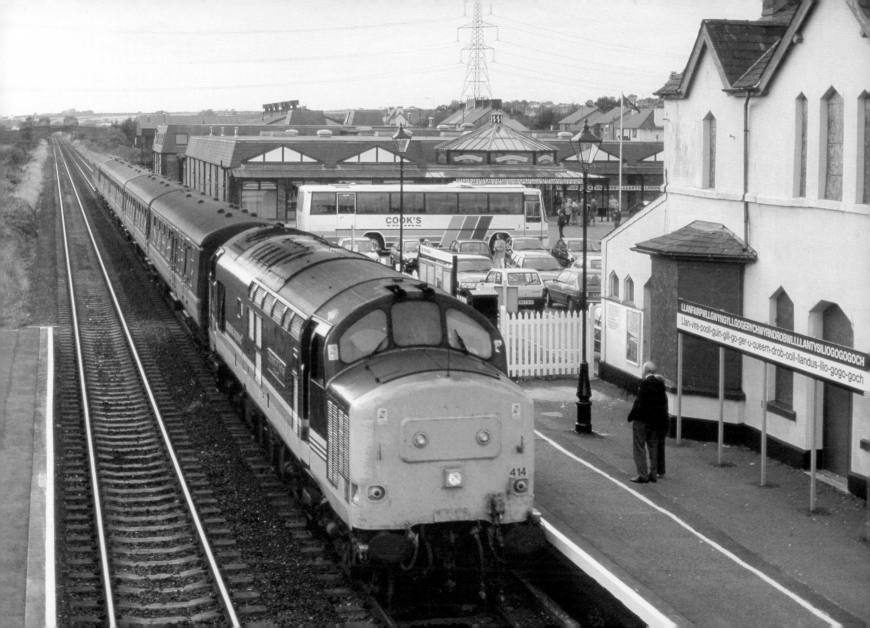

Right: Llanfair PG – Souvenir Tickets

Many thousands of souvenir platform tickets have been sold over the years – indeed, Llanfair PG station has probably sold more platform tickets than travel tickets! The Guinness Book of Records states that the station has the longest station name on probably the largest platform ticket in the world – the standard British Railways platform tickets, first issued in 1962, were 6 inches long. In addition to being available at the actual station, they were sold by post, and as souvenirs on passing trains. In recent years, souvenir bus tickets have also been introduced, an example being shown here.

Opposite: Llanfair PG

Class '40' locomotive No. 40145 approaches Llanfair PG with the 4.54 p.m. Pathfinder Tours Holyhead to Bristol Temple Meads 'Whistling Slater' railtour on 4 June 2005. The A55 Holyhead trunk road can be seen in the background. The station building is now privately owned.

Left: **Llanfair PG**

This postcard view, dating from around 1935, shows the down 'Irish Mail' passing through Llanfair PG. The locomotive was an un-rebuilt 'Royal Scot' class 4-6-0.

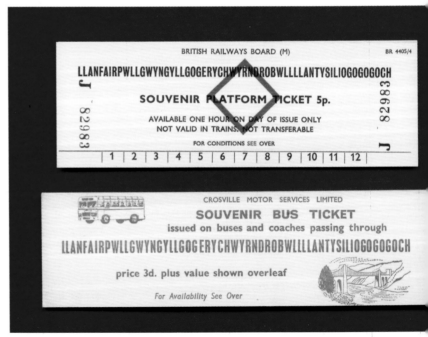

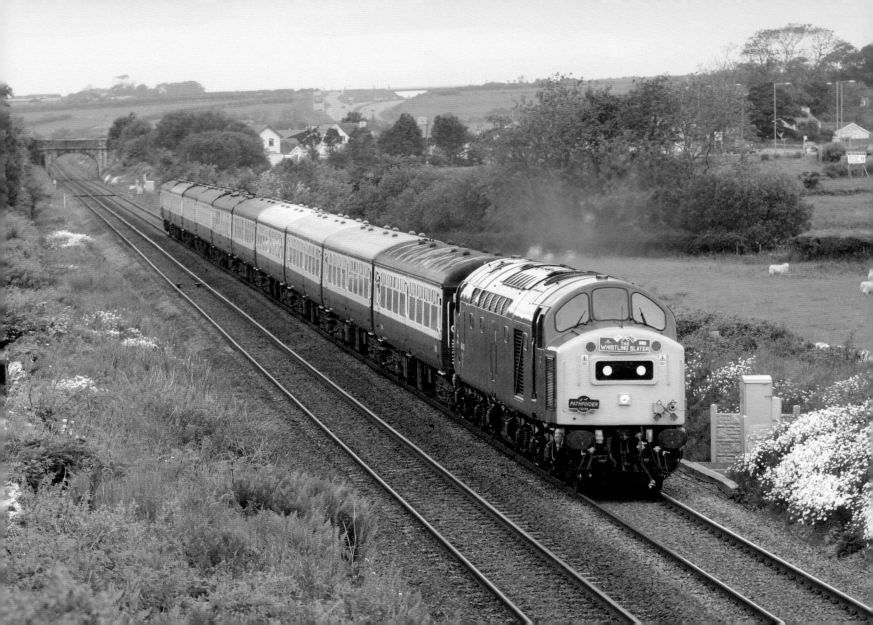

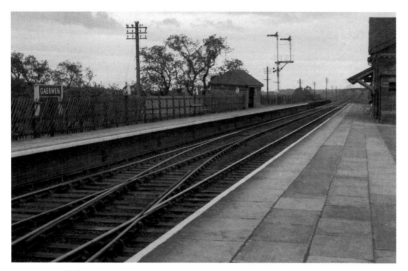

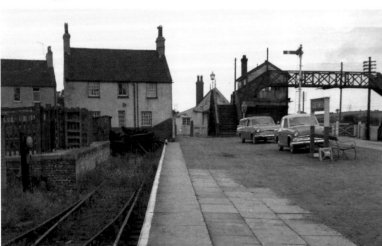

Gaerwen

Running through pleasant, but unspectacular, Angelsey countryside, down trains soon reach the site of Gaerwen station (87¼ miles), the junction for branch line services to Amlwch. As mentioned earlier, the Amlwch branch was opened as far as Llangefni on 8 March 1865, and completed throughout to its terminus at Amlwch on 3 June 1867. Although the Amlwch branch was closed to passengers with effect from Monday 7 December 1964, the line remained open for freight traffic until 1993 – the Octel chemical works at Amlwch being an important source of traffic.

Above: A general view of Gaerwen station, looking west towards Holyhead.

Below left: The east end of the bay platform used by Amlwch branch trains.

Below right: The Amlwch branch diverges north-westwards at the Holyhead end of the station. Gaerwen station was closed to passengers with effect from 14 February 1966.

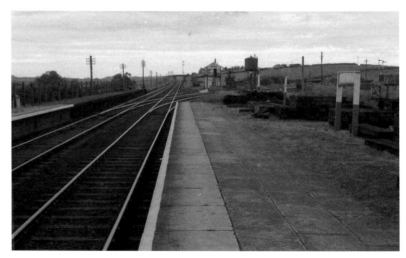

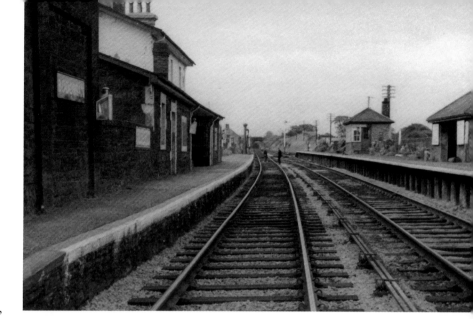

Bodorgan

After Gaerwen, the railway heads more or less due west as it descends towards the Afon Cefni, which is crossed on a low bridge known as the Malltraeth Viaduct. This is followed by a climb of 1 in 98 towards the still extant station at Bodorgan (93¾ miles), the station being preceded by two short tunnels.

With just a few houses for company, Bodorgan station is situated in the undulating Anglesey landscape between the villages of Bethel and Llangadwaladr. Up and down platforms are provided here and the main station building, of typical Chester & Holyhead design, is on the up side, while the down platform is equipped with a small waiting shelter. Other buildings on the down platform included a diminutive hip-roofed signal cabin with 36 levers (including spares), together with a water tower. The signal box was closed in October 1972.

Prior to rationalisation, Bodorgan's track layout had incorporated a small goods yard on the up side, the goods shed and associated sidings being to the west of the platforms, while the cattle loading dock was served by a separate siding at the east end of the station. The upper photograph, taken in the 1960s, is looking east towards Chester, while the lower view is looking westwards in the opposite direction.

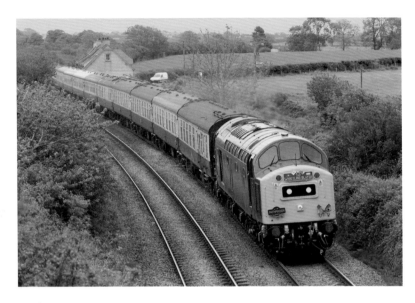

Bodorgan

Above: Class '40' locomotive No. 40145 passes Llangaffo, between Gaerwen and Bodorgan, with the 1.26 p.m. Pathfinder Tours Blaenau Ffestiniog to Holyhead 'Whistling Slater' railtour on 4 June 2005. Note the crossed spades on the front of the loco.

Right: Class '175' unit No. 175101 passes Llangaffo while working the 1.15 p.m. Crewe to Holyhead service on 4 June 2005. Unsurprisingly, given how close they are to the line, the cottages in the background are named 'Railway Cottages'.

Opposite: Bodorgan

Class '37' locomotive No. 37426 passes through Bodorgan station with the 1.23 p.m. Holyhead to Stockport service on 6 September 1997. The Chester & Holyhead station building, now a listed building, has survived, together with the nearby goods shed.

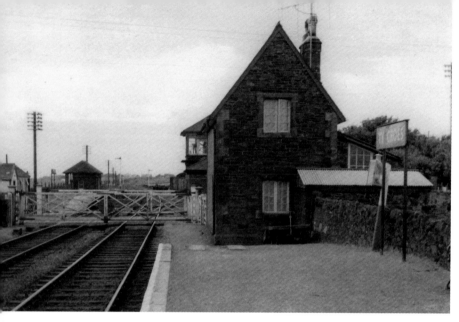

Ty Croes

From Bodorgan, the route heads north-westwards for a little under 3 miles to the next station at Ty Croes (96½ miles). The platforms here are staggered, the up platform being further east than its counterpart on the down side. The goods yard, which was closed in 1964, was on the up side, and the up and down platforms are separated by a level crossing. The upper photograph, taken around 1963, is looking north-west towards Holyhead. The cottage-type building on the up platform is the stationmaster's house, while the 18-lever signal cabin can be glimpsed in the background – the latter structure a hipped-roof design dating from the 1870s. The lower view shows the staggered down platform, with the single-siding goods yard on the opposite side of the running lines. The hip-roofed building on the down platform was built in the 1890s.

Opposite: Ty Croes

A wave from the driver of HST power car No. 43121, as the 1.38 p.m. Holyhead to Euston Virgin West Coast service speeds through Ty Croes station on 13 May 2000.

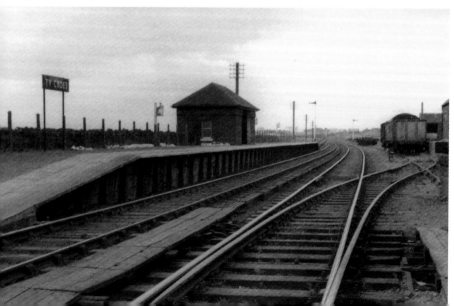

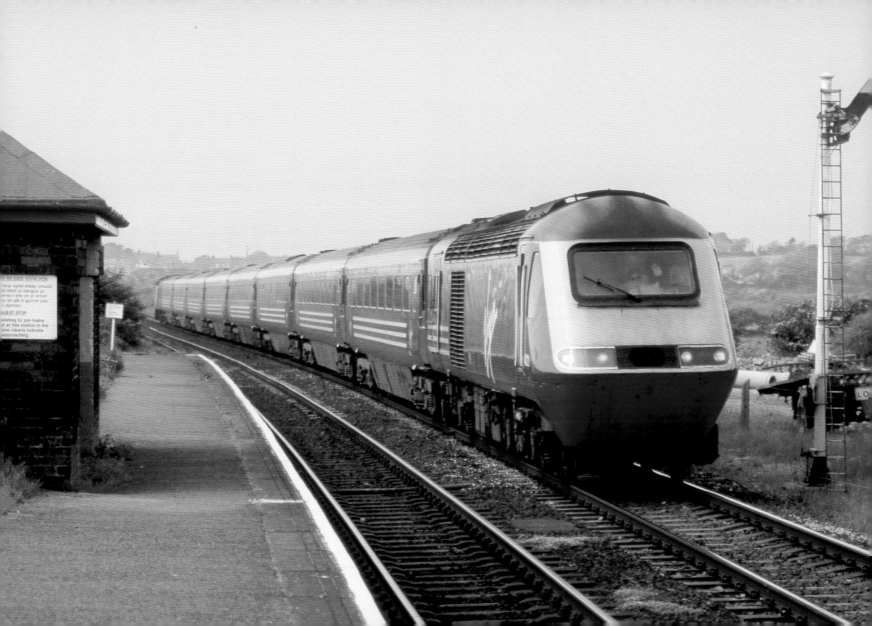

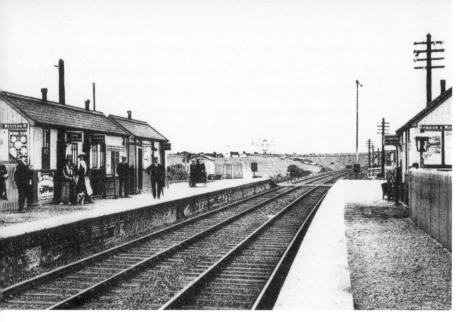

Rhosneigr

Rhosneigr, the next stopping place (98¼ miles), is a little over 1½ miles further on. Opened on 1 May 1907, this was always a passenger-only station, and no goods facilities were ever provided. Simple timber-framed buildings were available on both platforms and the main station building was on the up side, as shown in this Edwardian postcard view, which is looking east towards Chester. New brick-built buildings, of utilitarian design, were erected on both platforms during the early 1950s. The up side building still survives, albeit in a derelict condition, while a glazed 'bus stop'-style shelter has been placed on the down platform.

Valley

Class '37' locomotive No. 37429 *Eisteddfod Genedlaethol* is nearing journey's end as it passes Valley (102¼ miles) with the 1.23 p.m. Birmingham New Street to Holyhead service on 13 May 2000. Tywyn Trewan Common in the background is an important nature reserve, although at first glance it seems to be totally dominated by one single species – gorse! The railway is, at this point, skirting the RAF Valley aerodrome, which can be seen to the left as trains approach Valley station. Opened in February 1941, this airfield was initially used by Hurricanes of No. 312 (Czech) Squadron, defending the port of Liverpool, but it later served as a terminal for USAAF aircraft arriving in the UK from North America. It was also the home of an Air Sea Rescue squadron, while in the 1950s it became an important RAF training station – a role which has continued until the present day.

Opposite: Valley

Deltic class '55' locomotive No. 55019 Royal Highland Fusilier passes Valley at the head of the 3.57 p.m. Deltic Preservation Society Holyhead to Crewe railtour on 13 May 2000.

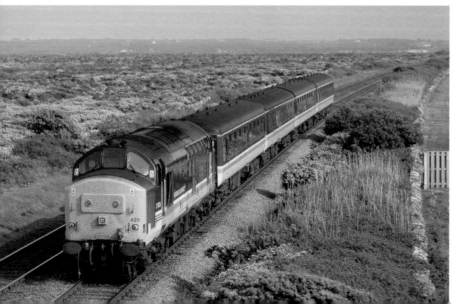

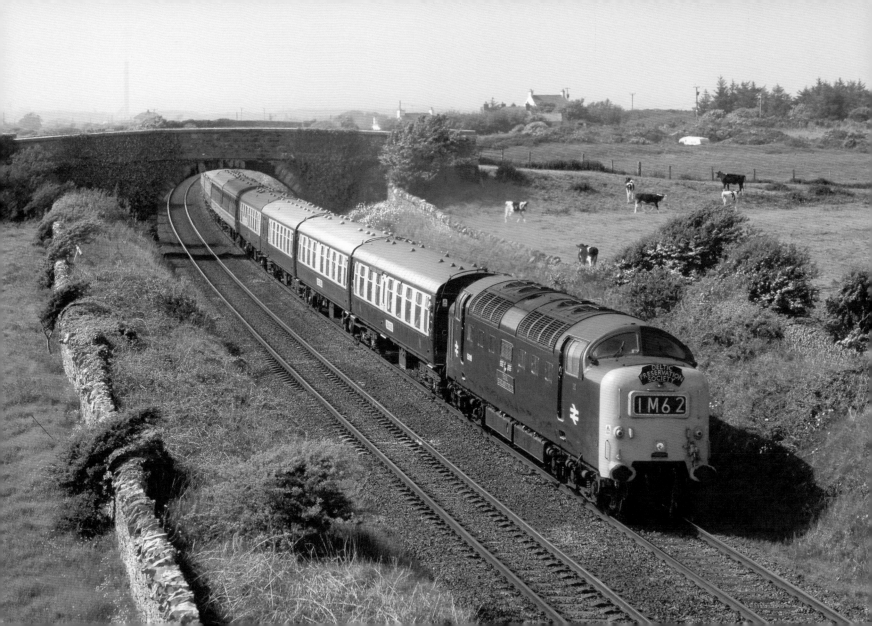

Valley

Opened in 1849, Valley is a typical Chester & Holyhead station, with two-storey station buildings of the now-familiar type on the up platform, and a level crossing immediately to the east. The goods yard, containing the usual coal sidings, goods shed and cattle loading pens, was sited on the up side, and there was also, at one time, a private siding link to a neighbouring corn mill. The photograph is looking east towards Chester with the all-timber signal box to the left. This standard L&NWR cabin contained a 25-lever frame.

Valley – Closure & Re-Opening

A general view of the station, looking north-west towards Holyhead during the 1960s, with the substantial stone-built goods shed to the right of the picture. Valley lost its passengers services as part of the 14 February 1966 closure programme, but the goods yard continued to be used as a loading facility for nuclear flasks from the nearby Wylfa nuclear power station. Meanwhile, there were repeated suggestions that the station should be reinstated and, following a locally based campaign, Valley station was ceremonially reopened on 15 March 1982, the first train to call being the 10.07 a.m. Llandudno to Holyhead service. The reconstruction was funded by Gwynedd County Council, with additional contributions from local community councils.

Opposite: Valley

Class '37' locomotive No. 37422 *Robert F. Fairlie* passes Valley as it gets into its stride with the 1.23 p.m. Holyhead to Stockport service on 15 June 1996. The scenery is typical of Anglesey, with scattered farms and an abundance of hawthorn and gorse bushes. The village of Valley can be seen on the horizon.

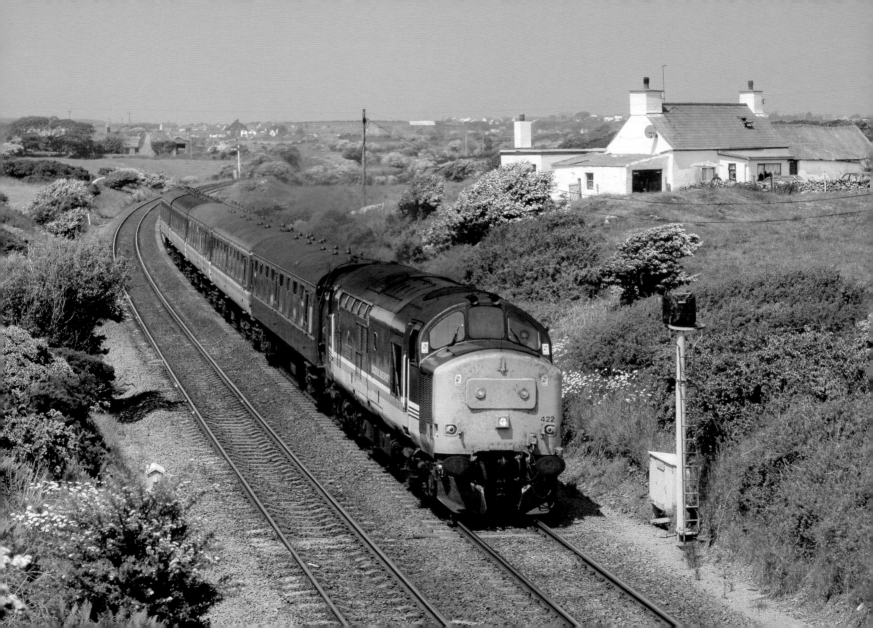

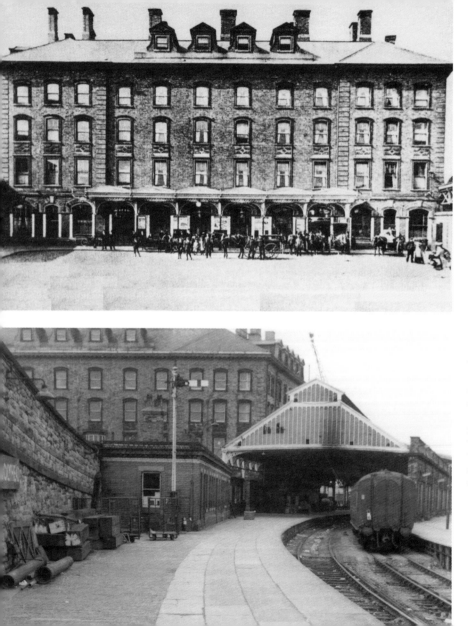

Holyhead

Holyhead station, 84½ miles from Chester and 105¾ miles from Crewe, was opened in 1848, but the present station is of somewhat later construction, having been brought into use on 17 June 1880. Until that date, all traffic had been handled in a one-sided station and quay, but as a result of a major improvement scheme that had started in 1876, the terminus was reconstructed with 'separate and distinct platforms, quay walls, goods sheds and sidings for the export and import of the harbour and the up and down traffic of the railway'. The area of the harbour was increased from 10¼ acres to 24 acres, with a uniform depth of 13 feet at the ebb and 30 feet at flood tides. The length of the quay was increased to 4,000 feet and there were no less than 15 miles of sidings.

The new terminal facilities were laid out on a roughly 'V'-shaped alignment, with two covered train sheds on diverging quays – the western shed being 'The Arrival Shed', while its counterpart on the east side was known as 'The Departure Shed'. A large and impressive hotel, 'replete with every comfort', was sited between the two train sheds, while the 'Inner Harbour' was laid out in such a way that the bows of incoming steamers were no more than a few yards from the northern façade of the sixty-five-bedroom hotel.

The upper view, from an Edwardian tinted postcard, shows the south frontage of the hotel, while the lower view is looking along Platform 2 towards the departure shed during the early 1960s. There were, at that time, two platforms within the departure shed – Platform 3 was added around 1906, while Platform 4 was an uncovered platform sited on the outside of the shed.

Left: Holyhead

Class '40' locomotive No. D333 stands alongside Platform 2 with a Holyhead to London train in June 1968. Another train can be seen in Platform 4, on the extreme right of the picture. The diesel locomotive would have hauled the train as far as Crewe, from where an electric locomotive would have taken over for the remainder of the journey to Euston.

Right: Holyhead

A view southwards along Platform 2, on the 'departure' side of the station, probably during the late 1950s. The sloping ramp that features prominently on the right-hand side of the picture enabled passengers and road vehicles to gain access to the station and hotel from the nearby road overbridge. The station was reconstructed during the 1970s and, in its present-day form, Holyhead has three operative platforms. Platform 1 is on the site of the now demolished arrival shed, while Platform 2 is situated within the departure shed, and Platform 3 is the uncovered platform on the eastern side of the station – the track beside the original platform 3 having been lifted. Platform 1 is normally used by main line services to and from London, while most other services use Platform 2. The hotel has, sadly, been replaced by a modern office block, but the ornate clock tower has been retained.

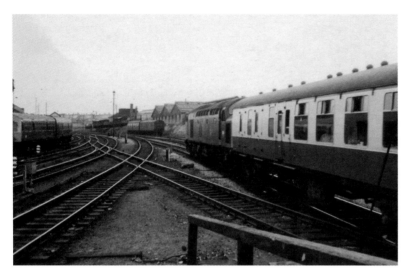

Holyhead

Above: An unidentified class '40' locomotive departs from Holyhead with a London train in June 1968. Holyhead motive power depot was sited to the left of the class '101' multiple unit that can be seen on the extreme left of the picture.

Below left: Class '37' locomotive No. 37298 passes the old water tower as it approaches Holyhead with the 12.20 p.m. down service from Crewe on 29 May 1999. No. 37298 was a member of the '37/0' sub-class – the rostered class '37/4' being unavailable.

Below right: An HST unit led by power car No. 43092 *Institution of Mechanical Engineers 150th Anniversary 1847–1997* prepares to leave platform 1 with the 1.38 p.m. Virgin CrossCountry departure for Euston on 29 May 1999.

Opposite: Holyhead

Class '47' locomotive No. 47191 enters Holyhead station with a down passenger working on 25 July 1977. The former steam locomotive shed was, at that time, still intact, and this four-road structure can be seen in the background with a breakdown crane on one of the sidings.

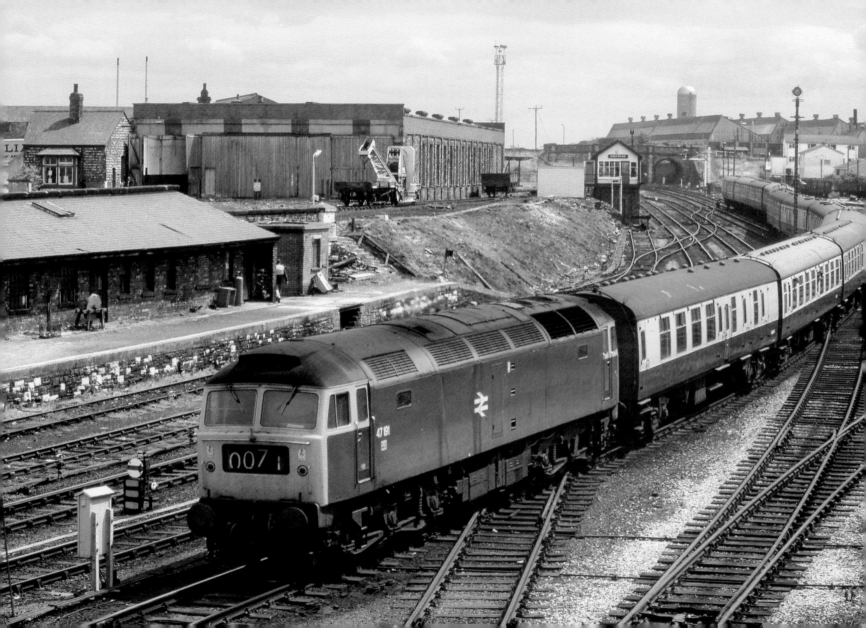

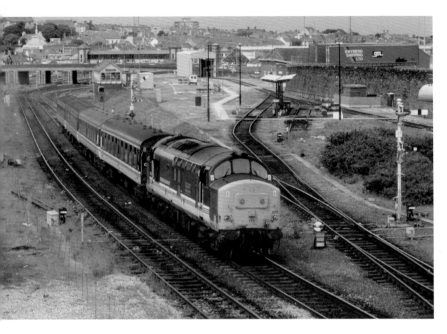

Left: Holyhead

Class '37' locomotive No. 37429 *Eisteddfod Genedlaethol* leaves Holyhead with the 1.54 p.m. Regional Railways service to Birmingham New Street on 29 May 1999. Holyhead's 100-lever signal box, built in 1937, can be seen in the background, with the diesel fueling point to the right. The latter facility occupied the site of the former steam shed which, in 1959, had boasted an allocation of nineteen locomotives, including five 'Britannia' 4-6-2Ts; two 'Royal Scot' 4-6-0s; eight 'Black Five' 4-6-0s; and four class '3F' shunting locomotives. The shed was closed to steam in 1966.

Right: Holyhead – The Harbour & Breakwater

This Edwardian postcard is entitled 'Divers at Work' and it shows dredging operations in progress in the inner harbour. Two London & North Western single-funnelled steamers are tied up alongside the extensive goods shed – these are possibly the *Rosstrevor* and *Connemara*, which carried both passengers and cargo, and were used on services to and from Greenore.

The infrastructure at Holyhead included a massive northern breakwater that extended north-eastwards for over 1¾ miles, and was equipped with its own railway (originally 7-foot gauge) so that large blocks of stone could be transported from a nearby quarry and tipped onto the seaward side of the breakwater as and when required. The breakwater railway was entirely detached from the rest of the BR system, and in its final years it was worked by class '01' 0-4-0 diesel locomotives Nos. D2954 and D2955; the line was last used in 1980.

Right: Holyhead

This *c.* 1930 postcard is entitled 'The Arrival of the Irish Mail', and it shows travellers boarding their train at Holyhead, having disembarked from the two-funnelled LMS steamer that can be seen alongside the arrival shed.

The vessel concerned is one of four sister ships, which were built by William Denny & Brothers of Dumbarton in 1920/21. They were powered by steam turbines and had an overall length of 380 feet, their gross registered tonnage being around 3,450 tons. These vessels were in effect, the 'third quartette' of Holyhead passenger steamers, which carried the traditional names *Cambria*, *Hibernia*, *Anglia* and *Scotia*.

Left: Holyhead – The Breakwater Railway

It is believed that this very rare photograph depicts a broad gauge locomotive on the Breakwater Railway – six 0-4-0s of this type having been constructed in 1852 by R. J. Longridge of Bedlington for service on the line. Engines of this type seem to have been favoured for work in the exposed conditions that pertained on the breakwater. After around twenty years of service, when the breakwater was nearing completion, five of the engines were sold, leaving *Prince Albert*, the last survivor, in use at Holyhead, where it worked until 1913. It is believed that the engines that were sold in 1872 were named *Cambria*, *Hibernia*, *London*, *Holyhead* and *Queen*. They were acquired by I. W. Boulton, a locomotive contractor, who seems to have sold at least one of them to the Harbour Board at Ponta Delgardo in the Azores. This veteran locomotive was at work in the 1960s, still bearing a plate with the inscription 'J & C Rigby Holyhead Harbour Works 1861'.

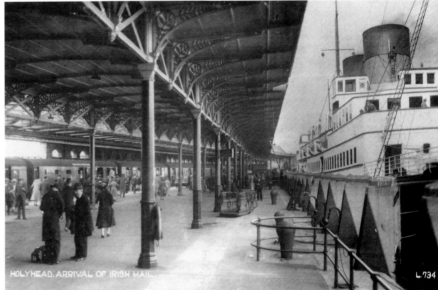

HOLYHEAD. ARRIVAL OF IRISH MAIL

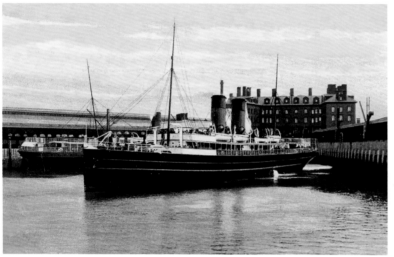

Holyhead

Above: A postcard view of *Hibernia II* leaving Holyhead, with the hotel visible in the background. Built by Denny Brothers of Dumbarton in 1900, this 1,862-ton steamer had an overall length of 329 feet and a top speed of about 21 knots. The vessel was taken into naval service as HMS *Tara* during the First World War, and in this role she was torpedoed in the Mediterranean on 5 November 1915.

Below left: The *Hibernia* had three sisters, the *Cambria III* having been launched in 1897, while the *Anglia II* and *Scotia II* were built in 1900 and 1902 respectively. This early twentieth-century postcard shows *Scotia* leaving Holyhead. Having served as a naval vessel during the First World War, the *Scotia* was renamed *Menevia* in 1920, and remained in service as a railway steamer until 1928, when she was sold for scrapping.

Below right: A broadside view of *Anglia III*, one of the 'third quartette' of Holyhead passenger steamers. These London & North Western vessels had black hulls and white upper works, their funnels being buff-yellow with black tops.

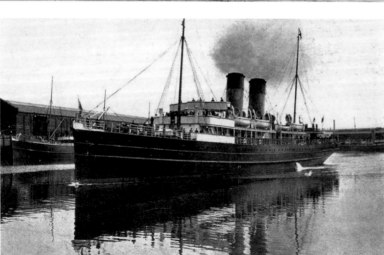

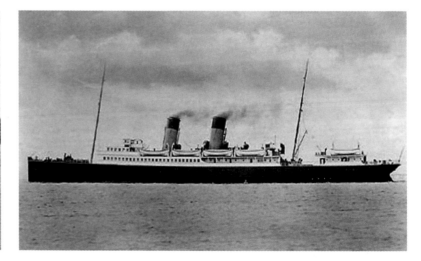

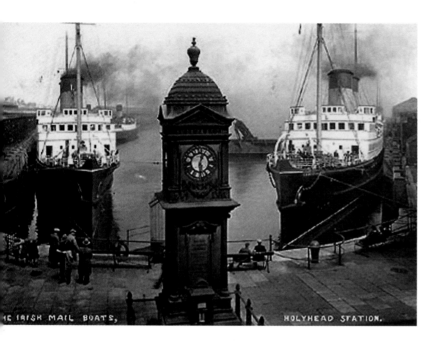

IG IRISH MAIL BOATS,　　　　HOLYHEAD STATION.

Left: Holyhead – The Inner Harbour

This postcard shows two LMS steamers (probably *Hibernia III* and *Scotia III*) moored in the inner harbour during the early 1920s. The elaborate clock tower was erected to commemorate the completion of the new harbour works at Holyhead harbour, which were formally opened by the Prince of Wales (later King Edward VII) on Thursday 17 June 1880.

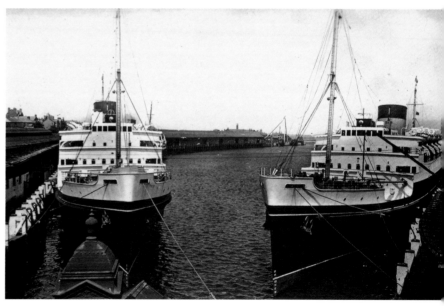

Right: Holyhead – *Cambria V* & *Hibernia IV*

In 1946, shortly before nationalisation, the LMS Railway ordered two 5,000-ton motor vessels from Harland & Wolff of Belfast. These were placed into service under British Railways auspices in 1948, and they remained in operation as part of the BR (later 'Sealink') fleet until 1975 and 1976 respectively, when they were sold to foreign owners. The vessels are shown in the inner harbour, the top of the clock tower being visible to the left.

In July 1984, the Conservative government sold Sealink to the Bermuda-based Sea Containers Ltd for the scandalously low price of £66 million. Less than five years later, on 31 May 1990, the bulk of Sealink British Ferries' operations passed to Sweden's Stena Line for £259 million, the privatised owners having pocketed many millions of pounds.

Right: Holyhead – The *Hibernia IV*

A broadside view of the *Hibernia* at Holyhead during the 1950s. In 1964/65, the *Hibernia* and her sister were reconstructed, some of the cabins and staterooms being replaced by additional lounge accommodation, while the cabins on 'D' deck were removed to allow room for a new smoking room and cafeteria. At the same time, the plating on 'B' deck was extended further aft to provide extra covered seating areas. As a result of these alterations, the number of sleeping berths was reduced from 436 to 357. These internal changes were accompanied by the introduction of a striking new 'Sealink' livery, incorporating 'monastral blue' hulls, 'pearl grey' upper works and red funnels – the funnels being further distinguished by the addition of BR 'double arrow' logos.

Left: Holyhead – *Cambria V*

MV *Cambria* leaves Holyhead on her way to Dun Laoghaire (formerly Kingstown) around 1949. The *Cambria* could carry 750 first-class and 1,250 third-class passengers, first class travellers being accommodated in a mixture of one-berth, two-berth and 'open-berth' cabins, while two-berth, four-berth and 'open-berth' cabins were also available for third-class travellers. There were, in addition, four deluxe suites, together with lounges, smoking rooms and dining rooms for both classes. At the time of their launch, the *Cambria* and *Hibernia* were the two largest cross-channel vessels operating in the British Isles. They had an overall length of 397 feet and a top speed in excess of 21 knots.